Making PHOTOGRAMS

Making PHOTOGRAMS
The creative process of painting with light

by VIRNA HAFFER

with an introduction by JACOB DESCHIN
Photography Editor, The New York Times

THE FOCAL PRESS
LONDON & NEW YORK

SBN 240 50692 8

First published 1969

Printed in Great Britain lithography by
The Redwood Press Limited, Trowbridge & London,
and bound by G. & J. Kitcat Ltd., London

CONTENTS

INTRODUCTION

The photogram goes back in noble lineage to the year 1839, when William Henry Fox Talbot, the Englishman who invented the negative-positive process of photography, made a 'photogenic drawing' of a piece of lace without a camera simply by placing the object on a sheet of light-sensitive paper.

Decades later, the basic principle was employed by Christian Schad (1918), Zurich Dadaist, to produce what he called 'schadographs', and about three years after that, two painters, the American Man Ray in Paris and the Hungarian Laszlo Moholy-Nagy in Berlin introduced light-modulation techniques by adding three-dimensional objects to create, respectively, 'rayographs' and 'photograms'. In recent years, Gyorgy Kepes at the Massachusetts Institute of Technology has named his efforts in this field 'photo-drawings'.

Today, the consensus is that a photogram by any other name is still a photogram. More to the point is how the basic technique is explored along creative lines, and the quality of the results produced. In these efforts Virna Haffer can be both guide and inspiration.

The portfolio that follows suggests the endless potentials of the medium, the technical how-to details are specific, easy to follow and within the capacity of any age level and artistic ability. With much truth, one might even say that the photogram is a certain and effortless means of exploring individual talent and of developing latent gifts in creative directions.

Although Virna Haffer's work can be appreciated simply as a picture book of delightfully conceived images, it will probably have a wider audience among those who would like to use it primarily as an intensively illustrated 'short course' in the making of photograms.

To this end, only minimal familiarity with basic photography will be required. Where lacking, this is easily and quickly remedied by reading the special chapter at the end of the book which explains how to do it. For the actual work, one needs a dark room, a supply of photographic paper, a light source (not necessarily an enlarger head, although this is the most convenient), trays of developing-and-fixing solutions and, of course, an assortment of materials with which to make photograms.

9

It is suggested that to make the most of this book, it is best to begin with the simple techniques, concentrating on each in turn, then going on to the somewhat more complex ideas and combinations of techniques.

Virna Haffer's richness of ideas, ingenuity, resourcefulness and skill should be a constant source of encouragement and direction on the way to mastery of what is surely one of the most inviting ways to exercise and flex the imagination, eventually perhaps to reach a sense of artistic achievement.

But whether used for visual enjoyment or for instruction, the book will be enjoyed for what it is essentially—an album of uniqueness and beauty by an artist and craftsman.

JACOB DESCHIN

PAINTING WITH LIGHT

To some extent every creative achievement of the artist is an expression of himself, what he feels, what he wants to say or convey. It may be a simple statement: 'This is a pattern picture, I think it attractive, interesting. It is my creation.' Or it may be a more complex one—one that carries a message. Or it may be satire, or just plain fun.

To that extent every serious creative effort is some kind of expression, is something he has to say.

The desire or compulsion to create is instinctive in most of us, less in some, more in others, still more in many.

The painter's urge is expressed with his brush on canvas, the sculptor with his chisel, the ceramist with clay, the photographer with *his* tools of trade.

Cameraless photography, shadow-gram, rayograph, light painting, photogram, whatever name one wishes to give it, is almost completely a creative process. When an object is placed on sensitized paper, an exposure made, and the paper is developed and printed, the result is called a photogram.

Basically the process is quite simple.

As this form of photography affords almost complete control of contrast, choice of content, form and composition, it becomes an excellent and most flexible outlet for creativity.

Subject matter can be non-objective, fantasy, abstract, realistic, scenic, still-life, pattern, story telling—almost limitless in its possibilities.

A photogram is the creation of the photographer and is as legitimate an art form as any of the other arts.

But it can be good or bad too, as can photography.

As one becomes more proficient and skilled, ideas are formulated with less effort. As you become more able to compose and render things as you want them, photography becomes a better and more efficient outlet for self-expression. An urge, a desire to create (and who hasn't got one?), a lot of patience, many trials and errors—and there it is!

We add something to each and everything we do. Inevitably our pictures become a reflection of what we think, of what we feel and of what we are. We change and our pictures change.

Photography is magic. It never ceases to be. It is young, is still in the process of evolving. It has changed considerably in the past and will change more. It is now accepted as an art and there is no foreseeing what the future holds. It may soar to undreamed of heights in technology, in its power of artistic expression and in its role in scientific exploration. The prospect is rosy, the sun is rising and for the photographer it is early morning.

THE MECHANICS
OF PHOTOGRAMS

To explain the mechanics of making photograms it is best to begin with the method in its simplest form. Those uncertain of printing fundamentals or wishing first to examine the kind of printing technique required for successful photograms should turn to page 106 where detailed coverage is given to this subject. Those already practised in producing photograms who, however, obtain unsatisfactory printing quality could make good use of that chapter to find out, if possible, where they are going wrong.

The method of producing a simple photogram is to position an object on paper which is placed on the enlarging easel, to expose the paper to light and finally process the result. The work is carried out in the darkroom.

Before making the first photogram, an initial test is essential to determine roughly how little light to give the paper to achieve its full black.

Cut a long strip of paper and lay it on the enlarging easel. Choose a medium aperture on the enlarger for example and cover the paper, all but an inch or so at one end with a piece of thick card. Give a brief exposure, say 5 seconds then move the card an inch or so down the strip and give another exposure of the same duration. Carry on along the strip giving exposures, each of the same length, until you reach the end. The strip has received exposures ranging from, in the example quoted, 5 seconds to perhaps 40 or 50 seconds at regular stepped intervals. Now develop the print. If the strip is not pure black anywhere along its length, even at the darkest stage, make a new start with longer times for each step, say 10 seconds. Alternatively, use a longer strip and simply add further steps of the original duration. The first exposure stage that gives a pure black is the guide exposure to all photograms you make, unless you subsequently change the stop or the kind of paper in use. A new test should be made for each grade of paper, and it should be remembered that a grade of one brand does not necessarily correspond with that of another.

Having established the minimum exposure time to get a black, you may find that this is so short that you would not be able to give shorter exposures (to obtain various shades of grey) accurately enough to control their effect. If so, stop down the enlarger lens to

a smaller aperture. For each stop, the exposure time necessary is doubled. For example, 15 seconds at $f5.6$ becomes 30 seconds at $f8$ or 60 seconds at $f11$. By adjusting the lens stop, try to make the exposure for black 30 seconds or any larger figure that can conveniently be divided by 10. This will break the exposure up into 10 equal 'units' which is convenient when working out exposures for more complicated photograms as we shall see later.

Now place a leaf on another sheet of paper and give the 10 exposures once again. Remove the leaf and develop the paper. It should give a clear white in the totally opaque areas of the leaf and a completely black background. Although this is, in itself, only a very simple photogram, it contains the basis for many other effects. Photograms are not always pure silhouettes of objects placed on the paper.

The partial translucence of these objects gives various effects according to the exposure, and is one of the chief attractions of a photogram. If there is translucence in the object which you do not want to appear in the print, use a harder grade of paper (see page 114).

making the first photogram

Some clean white fish bones saved from a beachcombing expedition might serve for an initial simple pure silhouette photogram.

They are arranged on a sheet of printing paper in this case to make the eyes, nose, mouth, etc., of a face which was the first thought to come to mind. Now the paper is given the maximum black exposure you have established.

When the print is developed a white face shows up against a totally black background (page 23).

two tones

The preparation of a two tone print is almost as simple as the straight white-on-black example, except that several items must be added to it. For this, a sheet of glass is needed. It should be plate glass for strength.

The sheet of glass should be several inches larger than the paper to be used.

Also you need a set of children's building blocks. These are placed at each corner outside the print area, and the glass is laid on top.

Four rectangles are cut in a sheet of black paper and this is placed on the plate glass. Fish skeletons are then arranged on sensitized paper beneath these cut-out openings.

The object of this exercise is to produce a deep black in those parts of the print beneath the four rectangles and a light grey over the rest of the background.

Working from the 10 'units' (say in this case they are 5 seconds each) of exposure mentioned above, subtract one unit (5 seconds). Expose the paper for 45 seconds. Because I have a repeating timer linked with the enlarger light I give this in nine 5 second exposures. This timer is set to 5 seconds and each time the button is pressed the light comes on for 5 seconds without resetting. If you use a clock, or a timer which must be reset for each exposure, obviously it is more convenient to add the repeat exposures and give them in one go—in this case you would give one 45 second (nine units) exposure. Now remove the black cut-out, and make another exposure to complete the full 10. Brush off the skeletons and develop the print. The result is the skeleton pattern (page 27). When dried and mounted it is ready to hang on the wall.

from negative to positive

The next big step from the simple procedure just described, is to reverse the print. One may call the above example a negative, or first print. The best kind of paper to use for a first print is single weight glossy.

Although the procedure for making a first print is similar to a straight photogram, it differs in respect of your ultimate intentions. When making these one tries to visualize how it will look when reversed rather than how it looks at the primary stage.

After a negative is made and dried it is ready to be reversed.

Lay a foam rubber pad on the enlarger easel and a sheet of double weight printing paper on top of it, emulsion upwards. Lay the dried

paper negative emulsion down on top of this and a sheet of plate glass on top of that. There must be perfect contact between the two sheets of paper to get a print with well-defined image edges. So it helps if the glass plate can additionally be clamped down to achieve the maximum pressure on the paper sandwich.

Before you go further, make a small test print to find the best exposure. If you encounter unusually long exposures—a paper photogram negative can have a high density—increase the light output from the enlarger by removing the lens and lens mount or board. Be sure that this does not cause uneven illumination.

Any number of prints can be made from this paper negative.

enlarged images

Small objects, too small for the conventional method of making photograms, can be projected on to the paper and thus greatly enlarged. Anything small enough to go between the enlarger carrier and condensers can be used. Natural specimens such as gnats, flies, bees, grasshoppers, insect wings, produce the most intricate detail. Bugs, worms, stones or agates, cut thin, can be placed on the glass, inserted into the carrier and enlarged.

If the object is relatively thick, and therefore cannot be reproduced as a sharp outline or in sharp detail all over, the enlarger lens can be stopped down so that the depth of focus is at its maximum. Focus as best you can first, then stop down. You can check for sharpness by placing a sheet of paper on the easel, when even the dimmest image should be visible.

The basic test strip for making photograms discussed previously cannot be used here as the exposure will depend very substantially on the clarity of the specimen placed in the carrier, just as it would with an ordinary photographic negative. Obviously the translucence or opacity of one insect's wing may vary considerably from that of another.

Many patterns are not immediately apparent and you have to juggle with the subject to get the right result. It is sometimes just the spacing between objects that 'does it'. The negative produced in the above manner can be reversed in the usual way.

macrograms, micrograms

A rich field for experiment is the application of various pigments or chemicals to a sheet of glass (the carrier glass) or Cellophane. Many abstract forms and patterns can be produced in miniature on the glass and by enlargement made to cover the whole area of paper. Try spray, dried chemicals of all kinds, smeared Vaseline or water droplets. One could spend half a lifetime finding and printing these; it may take hours to see something of interest or it may pop up the moment the enlarger is turned on and focused.

During the search for an interesting pattern, a piece of plain white paper can be used to show up the image. When you have found a suitable pattern, turn off the enlarger lamp, and substitute a sheet of printing paper for the inspection sheet.

Different types of spray produce their own distinctive formations of pattern. As people react differently to such things, one person may see an image where another would pass it up completely.

Most spray patterns are more attractive as a negative print rather than a positive, probably because of the black background.

There is really no logical reason for calling these prints negatives, but they have to be identified somehow, so negative (the first print) seems plausible.

multiple tones

In order of complexity, the next step is the production of a photogram having several tones of grey in addition to black. An example of this is seen on page 109 where the four fish skeletons are each a little darker than the other. To do this, first lay a sheet of white paper on the easel. This sheet must be of the size intended for the print. Place four blocks, one at each corner of the print, to hold the sheet of plate glass. Position the glass. Now arrange a few bones (hoarded with loving care by the devoted photogramist) on this glass.

Take four more blocks and set these on the glass immediately above the others and then lay a second sheet across with another fish bone. Repeat this operation twice more and the set up is ready.

With the enlarger lamp on and the sheet of white paper in

position, you can see fairly clearly through these four layers of glass, well enough to arrange or adjust the composition. When everything looks right the enlarger light is switched off and a sheet of printing paper substituted.

There is, yet, a small problem of arithmetic. If the background is to print white (black on the negative) and 10 exposures are correct for this, the exposures for the toned areas must be worked out. In this example, four shades of grey are needed for the different fish. So 10 exposures are divided into four groups, for example: 2 and 2, and 3 and 3, which total 10, can be tried.

Make the first exposure two. Remove the top glass and bones. Give two more exposures, and remove the centre glass and bones, three exposures and the next glass and bones come off. Finally you give three exposures.

The result may not look up to much, but remember, this is only the negative. When this is dry, the test print can be made.

Is this print good? Is it bad? Should you begin again? Where is it wrong? Why? What about the arrangement? Can it be improved? Perhaps it was the timing of exposure intervals. Maybe it would be better if the exposures were 1 and 1, and 2 and 6, or some other combination. Experience shortens this kind of work, but even so, test prints on all negatives are usually necessary, for it is almost impossible to judge results purely by the negative alone.

toning or dyeing

Wherever toning or dyeing is mentioned, one always thinks of brown or sepia tones, and the kind of picture that goes with them. But to tone or dye *selected* areas of a print is quite another problem, and looks altogether different.

Take an example where an apple is to be made to appear red while the remainder of the picture remains untouched. After drying the print thoroughly paint the area surrounding the apple with rubber cement (gum). The parts covered by cement (the resist) will not be affected by the dye, but you must take care to ensure that the rubber coating completely covers the required area, without any untreated patches as these would ruin the effect. You can save on **18**

the amount of cement you use by painting only the portion of the print that has to be dipped.

Either a toner or a dye will work satisfactorily. The only disadvantage with toners is the limited range of colours available.

After the finished print is dipped and the desired strength of colour reached, take it out and wash it. This may take half an hour, but depends upon the kind of paper used.

The cement can be quite easily rubbed off after the print has been washed. For ease of application the rubber gum can be thinned with cigarette lighter fuel, and painted on with a brush. This is particularly useful when following intricate outlines.

drawing with light

It may be argued that using a flash lamp or torch to draw pictures on sensitized paper is not really photography. What does it matter? It's fun, and it certainly has a place in photogram technique.

Any lamp may be used, but the small pen-light type is obviously less cumbersome. Cover the end with a black mask, leaving only a pin-hole for a narrow pencil of light to emerge. The light can then be used like a pencil and you can draw on paper to your heart's content. In a way it is rather like charcoal drawing.

Drawing with light provides an answer to the question of what to do with old out-of-date paper that is never thrown away because, well, there may be *some* use for it in the future.

scenics

Scenic photograms probably come nearest to what might be called 'light painting', unless cut-outs are so considered.

To begin a scenic, lay a white sheet of ordinary paper on the easel board, and place a sheet of glass above it, on blocks high enough to allow the paper to be exchanged for a sheet of printing paper.

The 'ground' can be laid by sprinkling earth and gravel on the glass. This is rather messy and not really necessary, though. Torn paper works just as well and is easier to handle. A 'tree' can be

19 planted in the ground. The 'trees' in these examples (pages 95

'and 96) came from Nevada and Death Valley, U.S.A., but species are to be found in every country that will serve the same purpose. Sage-brush for example is suitable.

Place four more blocks at the corners to take a second glass. Several thicknesses of block may be needed to prevent disturbance of the materials already laid on the first glass. On this second glass make some more earth with torn paper and insert another tree. Add a third glass, more paper and trees, then a fourth. On this glass lay a sheet of cardboard with a round hole cut in it. This is the 'sun' in the picture.

The next step, after inserting the printing paper, is to work out the relative exposures. They will have to come as a result of guess-work and trial and error, because there is no other way. Try, say, three exposures for the sun, then remove the cardboard. Try two exposures for the next stage, but this is not a straightforward exposure. Take a sheet of card (not the one with the hole in it) and during the exposure gently shade the print area from the top to the horizon. Repeat this twice, and each time the two exposures are made lift one glass and a tree. Do not make a further exposure after removing the last glass and tree, as these are to be left unexposed, or plain white, on the print.

The resultant print is a negative. From this you make a print in which the plain white area becomes black and the graduation of tones is reversed. Shading the sky for a realistic effect, you should note that a sky tends to be lighter nearer the horizon. A slight graduation of this kind improves the result immensely.

cut-outs

A cut-out can be as simple as the simplest photogram, or it can be quite complex. It depends to a great extent on the subject matter. A cut-out gives a broad effect somewhat resembling posterization in normal photography, where the subject is reduced to three or four areas of even tone. A photogram is usually less detailed, more stark, and offers the advantage of additional tone control within the areas of even tone. Where, in a posterized picture any tone must remain totally flat, with cut-out photograms you can

print-in during exposure in almost any way you choose. The result can be quite startling if used in moderation as the graduated tone draws attention to itself and contrasts with the surrounding 'flat' areas (see page 75).

The shapes used in these photograms must be cut out by hand. Obviously people more skilled in this have an advantage. But there is no reason why shapes from existing photographs and press pictures should not be mounted on black paper, cut out and used in the same way. Simple geometrical shapes on the other hand need no skill in cutting out. You can build up interesting 'cubist' abstract designs with them in a photogram. The working procedure for a geometrical cut-out is as follows:

Place a tumbler upright on the sheet of printing paper (this is optional, but will add an area of varied tone). Set up blocks at each corner and lay a glass sheet across them, high enough to clear the tumbler. Take a sheet of black paper large enough to cover the glass sheet, and cut out a geometrical shape from the centre. Tape the sheet down to cover the glass. This will provide the white background in the print, against which the geometrical patterns will appear. Now cut out some geometrical shapes from more black paper and tape these by one edge to the edge of the glass sheet so that they hinge out over the picture area. These should be easy to move between exposures, but as a second or third attempt is often needed to get the best exposure they must fall back into their correct positions.

Now for the exposure. This will have to be a guess, initially. The uncovered centre portion might take about 5 seconds of the total time (10 units). Flap back one piece of black paper and add a further two exposures. Flap back another piece and give a further 2 units. Then remove the whole glass plate for one more exposure, leaving the drinking glass in place. The total exposure for the centre adds up to 10. The result may look something like the picture on page 77. Correct exposure is very important, it can make or break a photogram.

CREATIVE EXAMPLES

With a basic photogram where the subject is laid on the paper, the image is always the same size as the subject, and, provided the subject is totally opaque, a pure white shape should appear on a completely black ground.

If the subject is less than opaque in some areas these will print as a tone rather than pure white. Subjects with partially translucent features will print through, exaggerating these features giving a diagrammatic effect. The leaf, below, which has some transparency, is typical of this class of subject.

The leaf is placed on the paper and exposed the length of time it takes for a good black.

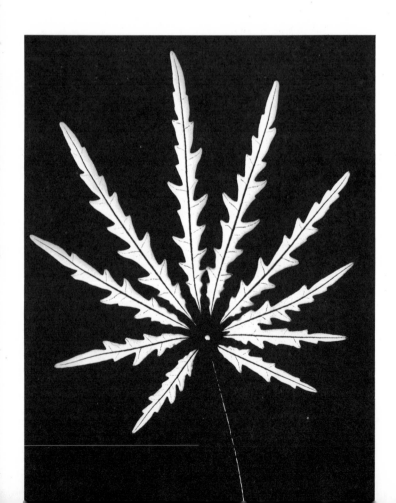

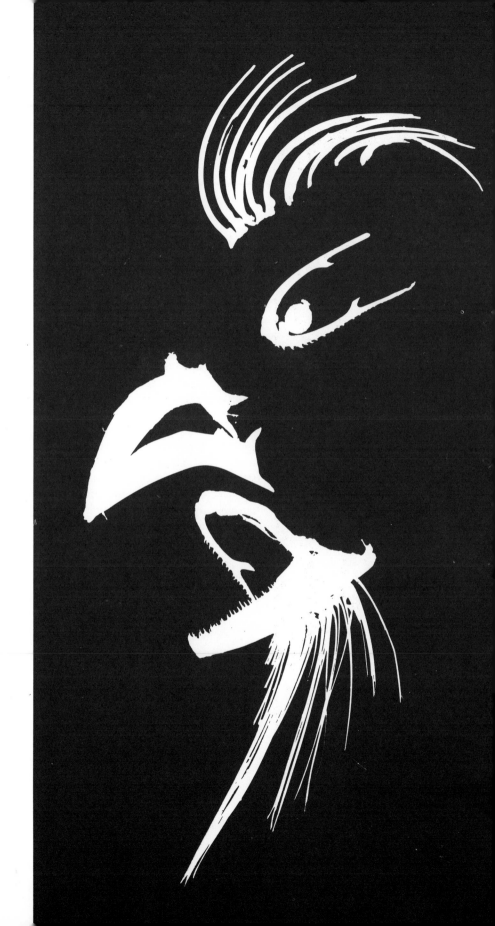

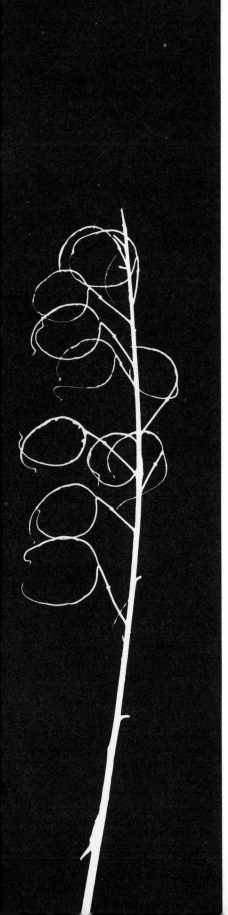

When the subject is in close contact with the paper the edges will always appear sharp. If the subject is raised from the paper the image will grow in size and the edges become less well defined.

With a 60 watt yellow safelight, it is quite easy to see the objects as you arrange them on the paper. 'The Old Man of the Sea' (page 23) was made by arranging fish bones, exposed for a good black and developed.

Such things as last year's dollar plant (left) that look so woebe-draggled out in the garden, and a few stalks of wheat make interesting pattern pictures.

Both are made by laying them on the printing paper, exposing and developing.

The tall narrow picture shape chosen for the ears of wheat suits the subject matter, and emphasizes their slim delicacy.

The intricacy of the dandelion docks, far right, with their fine hair-like radial seeds that the wind carries capriciously here and there, is always a wonder and something to marvel at. These were laid on the printing paper with a few seeds thrown around, then exposed and developed. Good composition often involves trimming well into the subject itself. It may be more effective than including the whole subject. Here the framing strengthens the arrangement considerably.

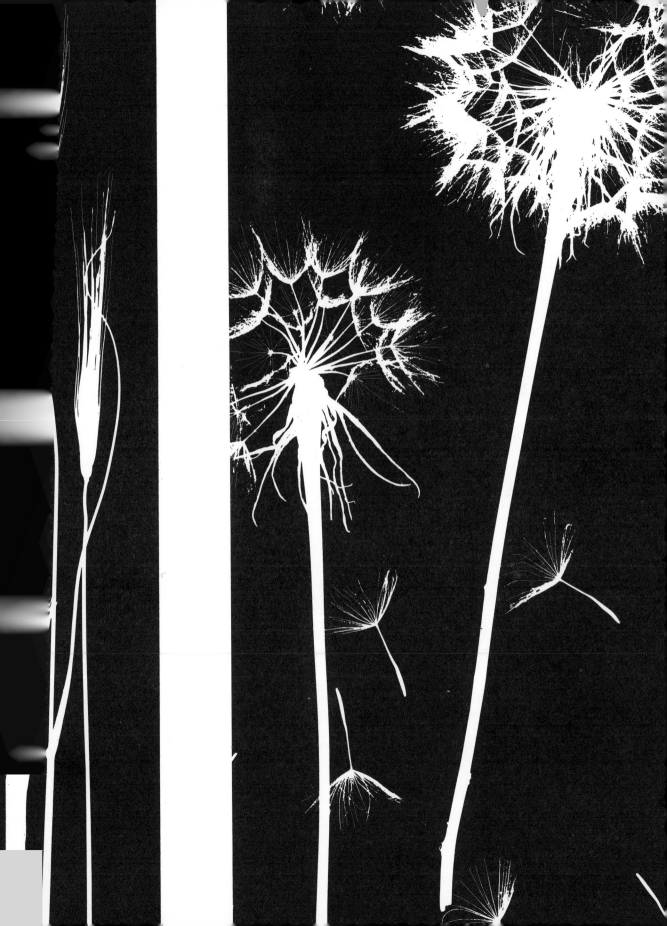

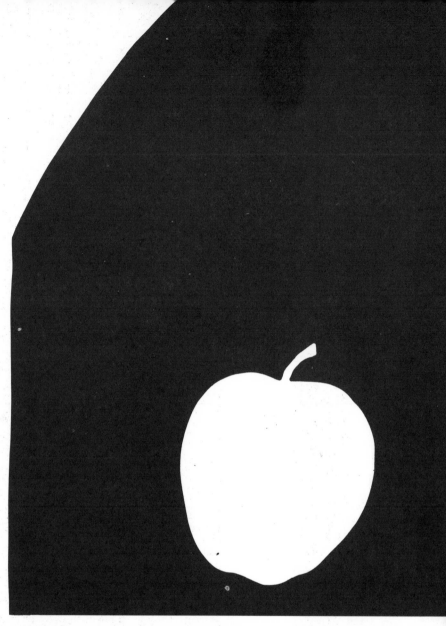

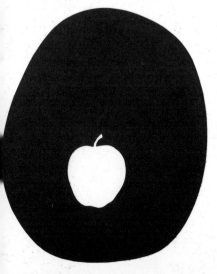

For the apples on this page a hole was cut from a 16 x 20 printing paper envelope. This was laid on a sheet of enlarging paper, and an apple was placed in the centre. It was then exposed and developed.

This print (the small one on the left) when finished, had no appeal. It was not specially pleasing and it clearly lacked something. So I experimented with different trimmings. When cut down to about 8 x 10, the arrangement as shown has impact and made an attractive pattern picture, where the former one had none. The paper was twisted round a little to angle the apple. A large enough white section was included to show the curve of the cut-out section. Be decisive with small irregularities of this kind. Make them look intentional, if they are so.

two tones or more

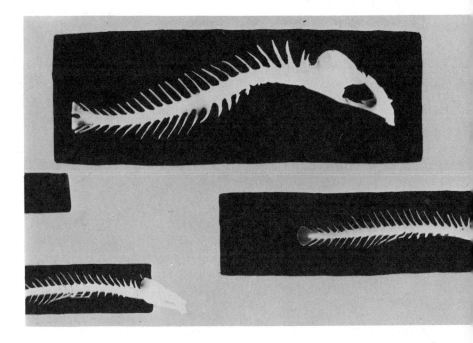

A rough sketch was made of the idea I had in mind for this picture (above). I cut four rectangles from a 16 x 20 printing paper package which I saved for the purpose. Next, the double weight enlarging paper was laid on the easel and children's building blocks were placed at each corner, just outside the paper area. A sheet of glass several inches larger each way than the paper was then placed on these, and the cut-out sheet positioned on top of the glass. Bones were arranged on the printing paper under the glass. Exposure was determined by the test strip method discussed on page 116. After the initial exposure the cut-out sheet was removed and another exposure made. The bones were brushed off and the paper developed.

This set-up (left) is similar to the one on page 27. Printing paper was placed under the sheet of glass which was supported by four blocks. The torn piece of paper (white part) was laid on the printing paper. Peanuts, squash and tomatoes were laid on top of the glass.

A timer, attached to the enlarger is a must, because short exposures cannot be accurately judged any other way. As so many of these examples need repeated tests, the tests can only be of value if they can be repeated exactly.

For this photogram, working on the basis of a total of 10 1-second intervals for a full exposure five exposures were first given, then the peanuts were removed. After one exposure, a tomato was taken off, another exposure and the other tomato was removed, a further exposure and the squash was taken off. The last exposure of 2 seconds was made with the paper still in place. The paper was then developed.

If the relative tones are not pleasing, the process can be done again with varying exposures.

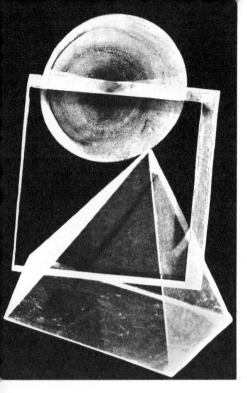

reversal

This really is where the fun starts. Until another print is made from this first one which can be designated a negative, the final one cannot be fully visualized.

A negative print is made by placing the objects on the printing paper, exposing the correct amount of time and developing. Single weight paper is best for negatives as the subsequent print is made by passing light through the paper. Glossy paper has no texture, so the result will have quite even tones but if texture is desired, any of the textured papers can be experimented with.

A foam rubber pad, about 24 x 30 (large enough for a 16 x 20 print) is laid on the enlarging easel. A piece of enlarging paper, double weight or any preferred kind the size of the negative, is then laid emulsion side upwards. On top of this goes the negative, emulsion down. To keep these two in perfect contact a sheet of heavy plate glass is put on top of the two pieces of paper and this can be held down with four small clamps. To shorten the exposure the lens panel can be removed from the enlarger, and having previously made a test on a small piece of paper, the correct exposure is now made and the paper developed.

The swamp grass picture opposite was made by the same neg.-pos. method.

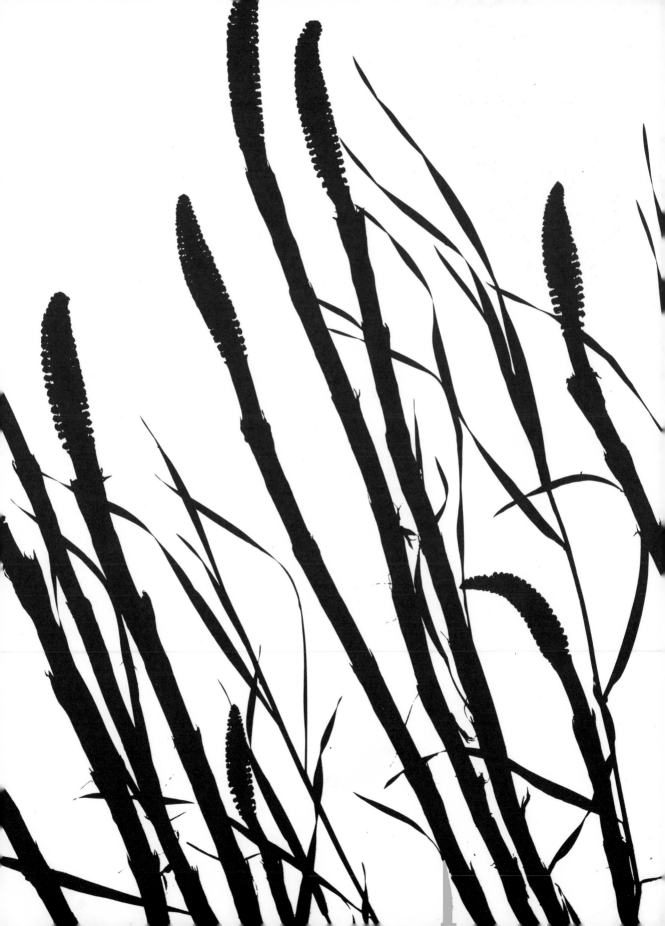

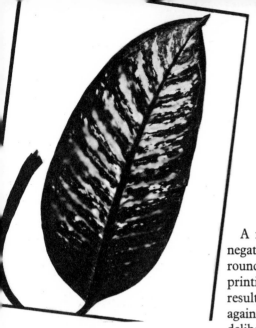

A negative was first made of the philodendron leaf (left). The negative was then trimmed, leaving a narrow white border all round. When making the positive this was arranged on top of the printing paper as seen here. A positive print was made, and as a result the narrow white border became black. The border was then again slightly trimmed, and the print was laid on white paper and deliberately angled to the frame.

For the doughnut shaped photogram opposite (top) a small stone was placed in the negative carrier and used exactly as one would make a print. It looked more like a negative, too much so, so it was reversed to a positive.

In such cases, where the object placed in the negative carrier has considerable thickness, it is too thick to be sandwiched between two glasses, for example, then even with the smallest aperture setting on the enlarger lens the object will not produce an all-over sharp image. Be careful with focus, and select the edges you want sharp and those you are willing to have fuzzy. Such selection depends very much on the qualities of the individual picture. Here, the narrow portion was considered the more important and so has the hard edge. It is possible, of course, by de-focusing to intentionally blur all edges.

The seed from a dollar plant opposite (bottom) was placed in the carrier and enlarged the same way as the stone. This was a translucent membrane that could be held flat in the negative carrier, and therefore allowed a sharp image all over. Exposure was

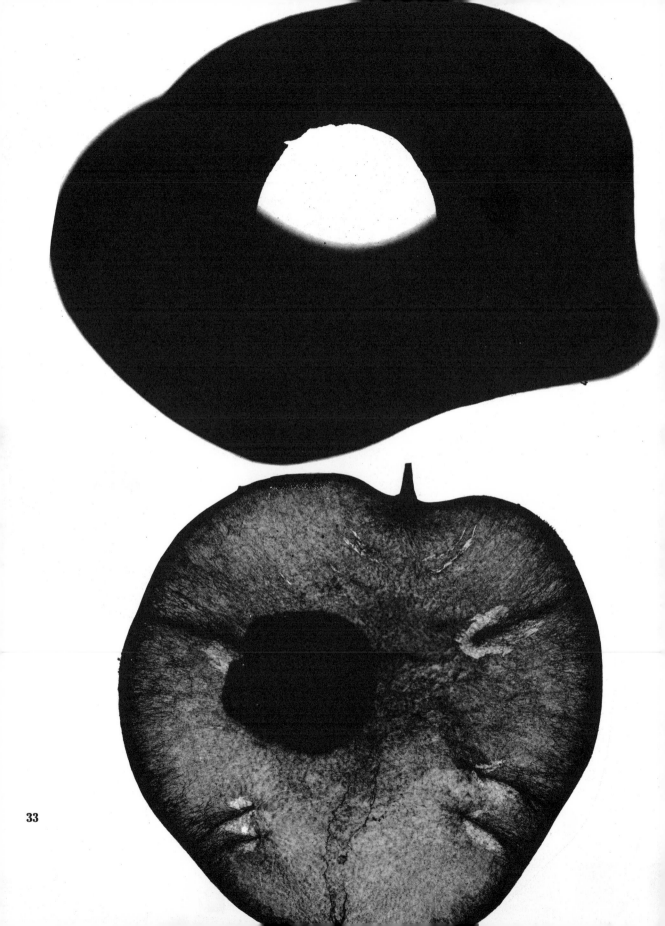

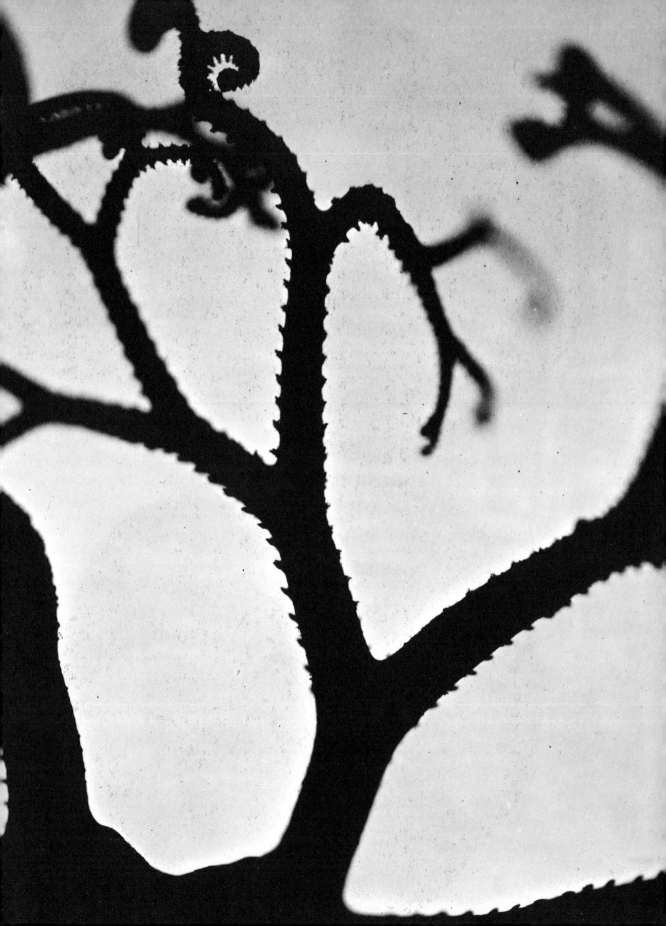

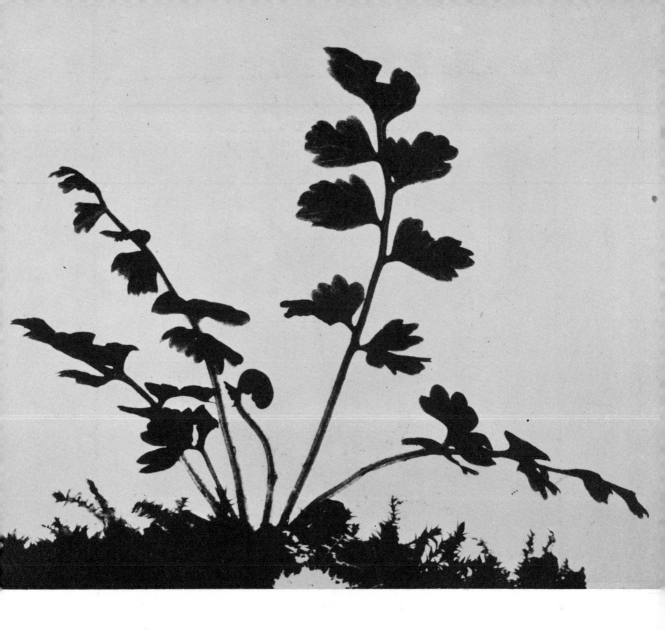

determined by the amount of detail to be seen in the centre, rather as exposure is determined by the density of a negative.

The 'Reptile Tree', left, was made from one arm of a deep water starfish. It was placed in the carrier and enlarged keeping the central area sharpest. A positive was made from this.

Life was just beginning for this miniature fern from the park— so tiny, only an inch high, that it had to be handled with tweezers. It was placed in the carrier and a negative was made as before.

When making the positive the same fern was placed on top of the negative as it was being printed. The small white image at the bottom (centre) shows the relative degree of enlargement of the main photogram image compared with the original.

35

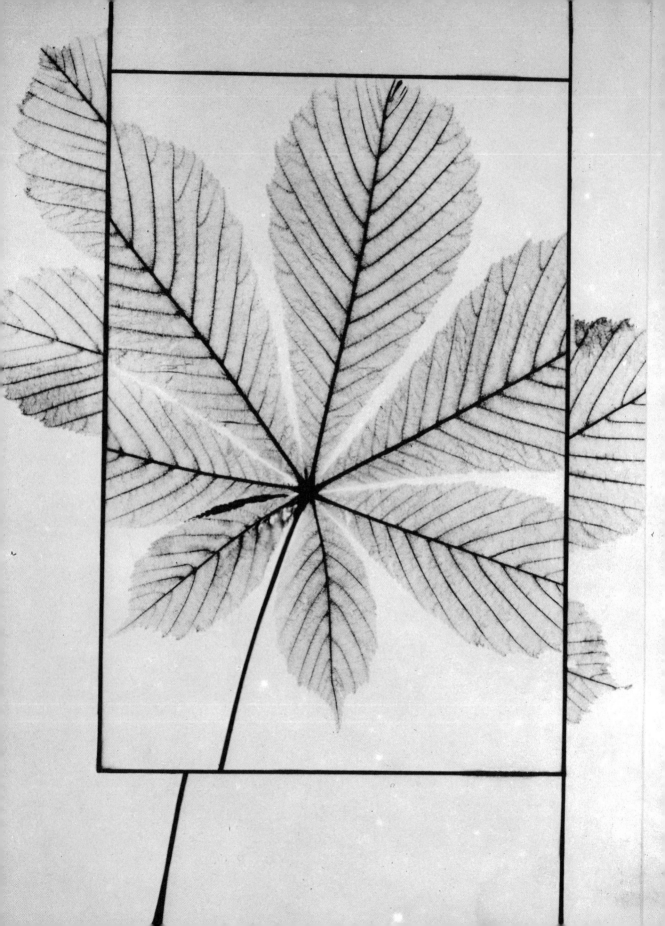

The negative of the leaf (left) was made as usual. The print was
then cut into pieces, and after slipping them sideways the pieces
were rearranged with narrow gaps between them, and used in
printing the positive as in previous examples. The tone of the leaf
was kept light enough to bring out the lines as a hard form which
contrasts with the grey and relates to the black rectangular surround.

The lacy pattern above came from a piece of moss, placed in the
carrier and enlarged in the same way as the doughnut stone on a
previous page.

Again, this is an example of a very small object benefiting from
enlargement. Small natural objects are almost unique in that very
great degrees of enlargement usually reveal pattern or textures that
were previously invisible. This is rarely so with non-natural objects,
which in contrast suffer a loss of quality. Nature seems to store an
almost endless series of forms within forms.

This result in a way resembles the photogram over the page,
which has quite another source, though also natural. I stood
watching a young man cleaning out a snake (boa constrictor) pen.
He was about to throw away the old skin which the snake had just
shed so I asked if I could have it. He reluctantly handed it to me
saying that it was really too dirty to be any good. Of course, this
meant nothing when there seemed to be such possibilities for a
picture. Here it is greatly enlarged.

While making some slides of plants, weeds, and berries growing
wild in Pt. Defiance—a natural park—I came across a beautiful
small, fuzzy plant. These are the stems—put in the negative carrier
37 and enlarged, then reversed.

multiple tones

The above composite photogram made from leaves from Korea
was a build-up of several layers of glass and leaves on blocks over
a sheet of enlarging paper. It began with one dark leaf placed on
a sheet of single weight paper on the easel board. Children's building **40**

blocks were placed at each corner beyond the printing area of the paper.

A sheet of glass was placed on these and above this glass several leaves, which the design called for. Another four blocks were placed on top of the first glass and a second piece of glass added, with the rest of the leaves. By turning on the enlarger light with the red filter over the lens, an image of these positionings showed up. Exposure for each step had then to be figured. With the total taking 10 3-second exposure intervals, at $f8$, it had to be divided into three as there were three layers of leaves, or tones.

This division of exposures determines the tone relationships. It is particularly effective if the strongest tone is confined to one item and the remainder are, by contrast, delicately varied. Here the density of the strong image is determined by the detail seen through the slightly translucent leaf. These densities are worked out with the final positive in mind.

After making a number of negatives and making positive prints from these you should accustom yourself to just what results can be expected from any particular negative. It is wasteful and tedious to produce positives for every negative attempt. So the art of judging negatives should be cultivated early in your photogram experience.

For the simple leaf and root picture, right, two weeds were laid directly on single weight paper. It was exposed for a portion of the time, then the smaller weed removed, the balance of exposure given and the paper developed. It was a relatively easy job, as one object did not interfere with another and could be laid directly on the paper. The positive print was made as usual.

This sort of composition may benefit from black border treatment, possibly placing the whole framed subject in a larger white, or toned area. Trim should emphasize the shape, that is, follow it. Wide borders on the long sides of a frame will always lessen the elongated effect of the subject itself. Even where the trim does not actually touch or cut the subject at any point a long frame makes a subject look longer.

The 'clockworks' on page 42 were made by roughly the same method as that on page 40. The picture of a clock face was first

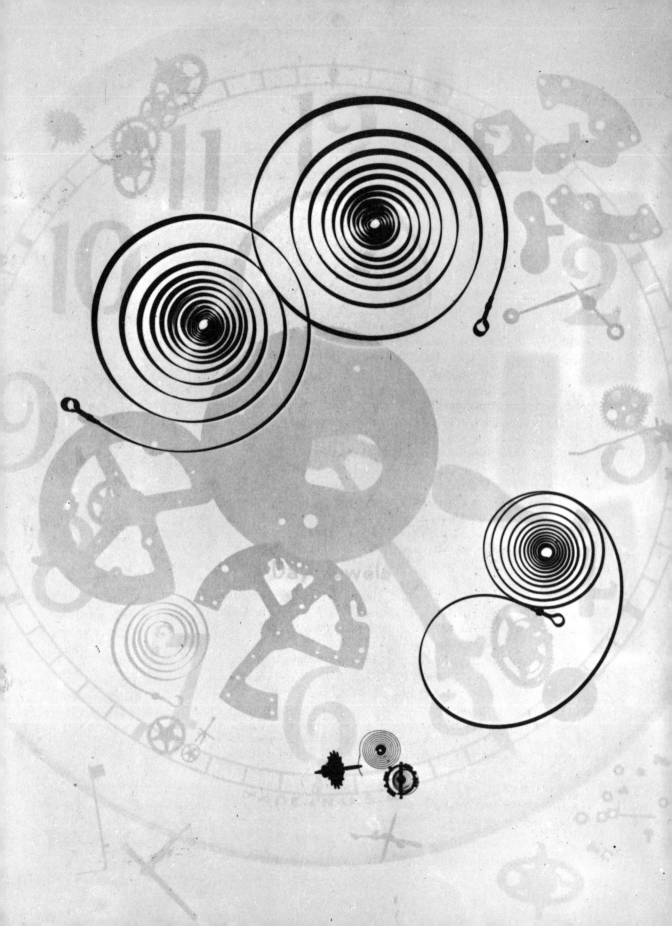

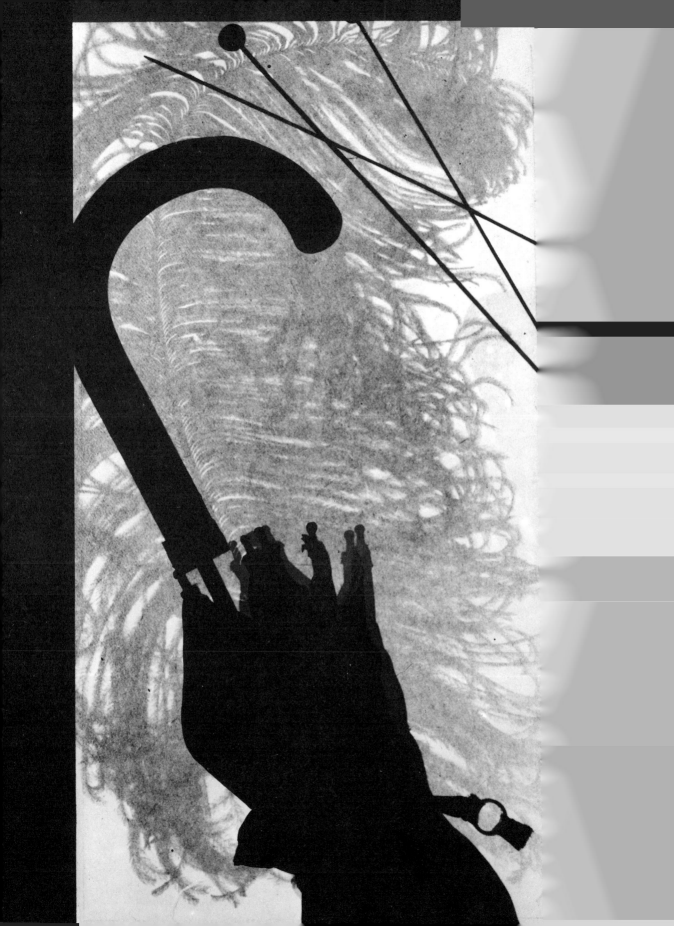

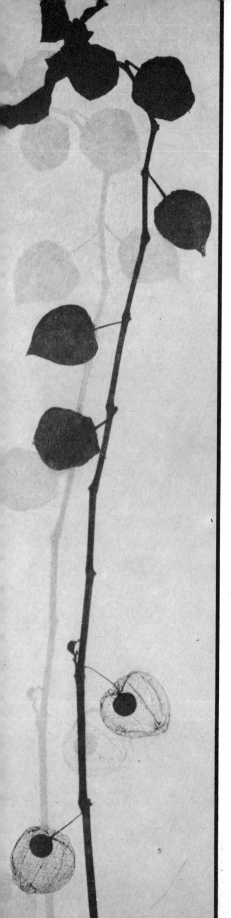

prepared using a camera. This positive was put in the carrier. An exposure was made and then it was removed. After another exposure the smaller wheels and springs were removed. A further exposure was given, leaving the springs on the paper. The total exposures added up to the time for a good black. The paper was developed and a positive made.

For the picture on page 43 an umbrella and a few old fashioned hat pins were laid on single weight enlarging paper. In each corner, beyond the paper two building blocks were used because the depth of the umbrella was more than the height of one block. A sheet of glass was put on top of the blocks and a feather laid on this. The exposure time was cut into two and the print reversed.

The Japanese Lanterns, left, were laid on single weight paper. The second stem of lanterns was added by the glass sheet method being in two parts. This print was the positive reversed from a negative.

The fruit photogram, right, was made by the same method as that on page 43. It proved that simple, and boldly drawn shapes

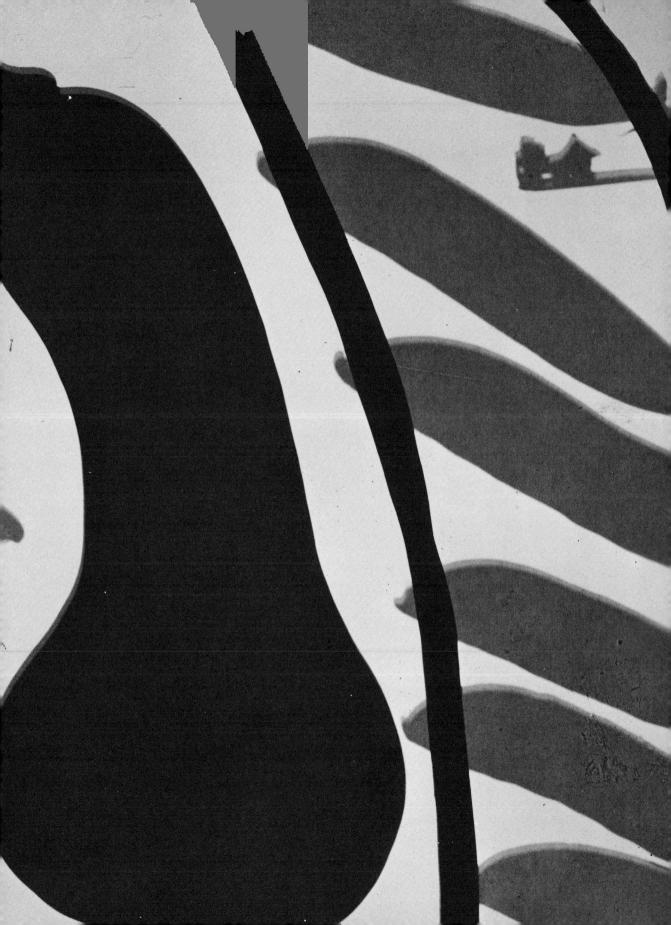

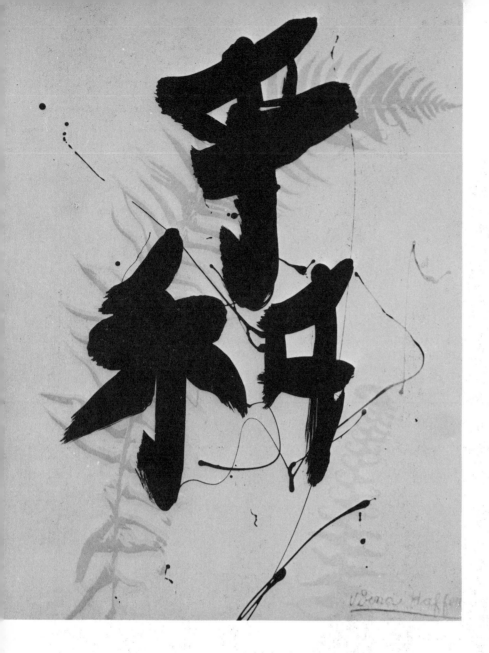

could be just as exciting to the eye as the more intricate plant-structure picture.

Lettering in the example above was made by painting a piece of single weight paper with rubber cement. The ferns were then put on top and the enlarger turned on. The total time was broken into three parts. After a partial exposure, the smaller and lighter toned fern was removed. Another exposure was made for the large fern and another without it. It was then developed. The rubber cement was rubbed off while the print was in the hypo because the whole area of the print should be fixed properly. When this was washed and dried, it was reversed to a positive.

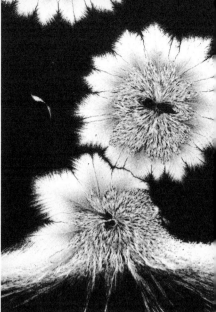

dried chemicals and spray

A sheet of glass, when treated with various substances sprayed on, can yield various pattern formations, stress lines or crystalline effects when magnified in the enlarger.

The process for all pictures on this page, the two following and the example (bottom left) on page 50 was as follows

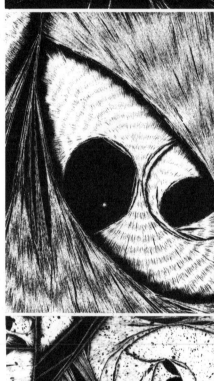

A Christmas glitter spray makes good patterns but there are many other sprays to choose from. Also, many chemicals can be dried on glass. Experimentation is often great fun but the repetition it involves can sometimes be tedious. A 4 x 5 glass sheet was used, but something near that size will do. The glass was sprayed, and when dry was put in the enlarger carrier. A sheet of plain paper the size of the print to be made was laid on the easel board. The trick was to manoeuvre the glass around in the carrier until an image appeared that looked interesting. The paper was substituted with printing paper. Usually double weight is best, as this kind of photogram is nearly always more pleasing in a first print than a reversed one.

You will have to experiment to find the most suitable kinds of spray, but a wide selection of industrial and domestic agents are nowadays canned under pressure. Those containing solids promise to be the most interesting, but the chemical sprays can be just as useful as the examples on page 50 clearly show. Here the sprayed chemical was allowed to dry and various crystal formations which appeared were used as a basis for photograms.

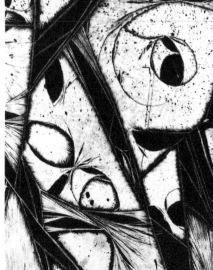

The pictures (top right and left, and bottom right page 50) were made the same way as previous examples except that they were done on single weight paper and then reversed. A comparison between

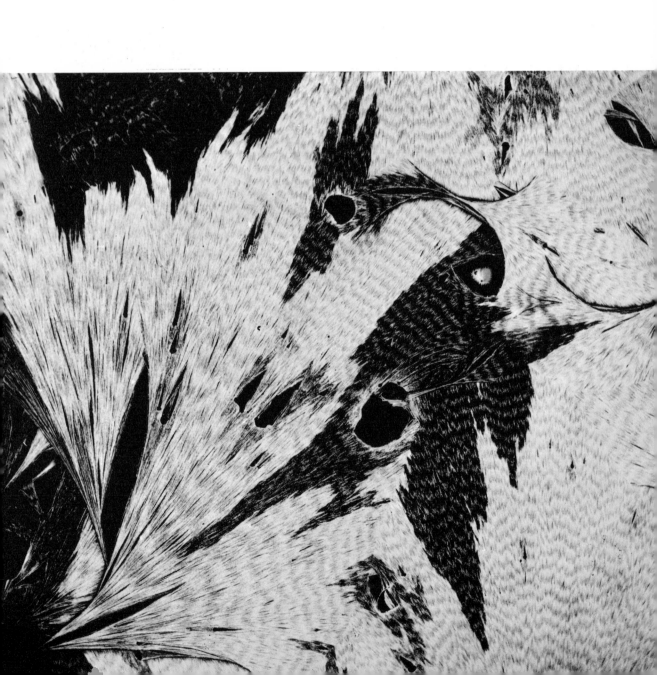

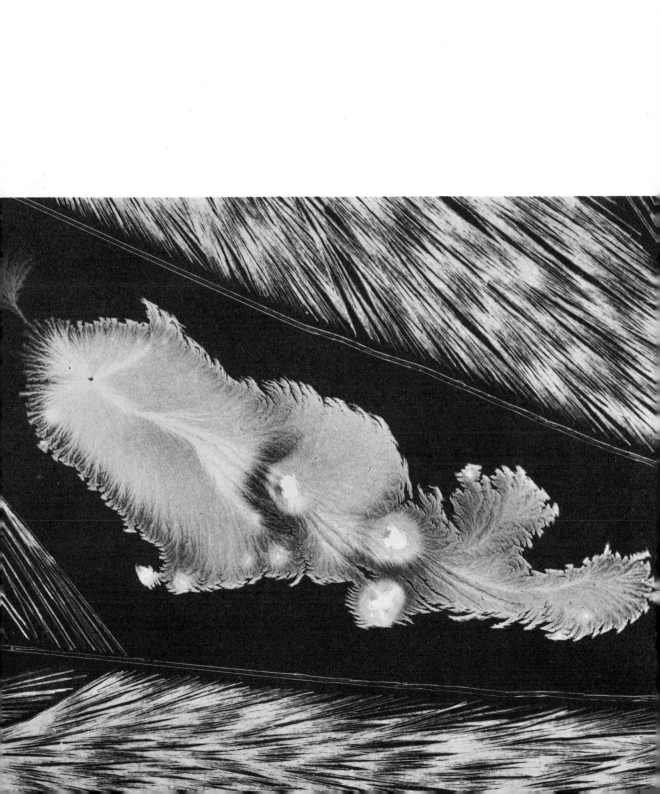

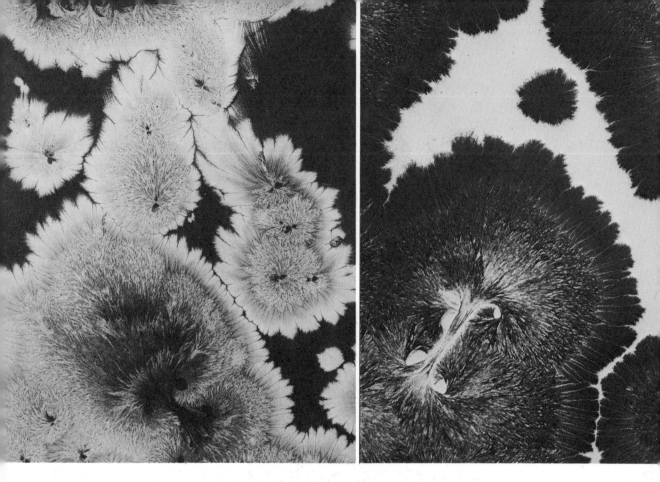

the effects of negative and positive prints of the same substance (though not the same picture) could be made in the two examples below. Although in this instance it worked with either treatment, the choice of negative or positive for pictures in this book was determined by the picture itself rather than the particular substance in use. It was done purely by inspection, a combination of luck and judgment.

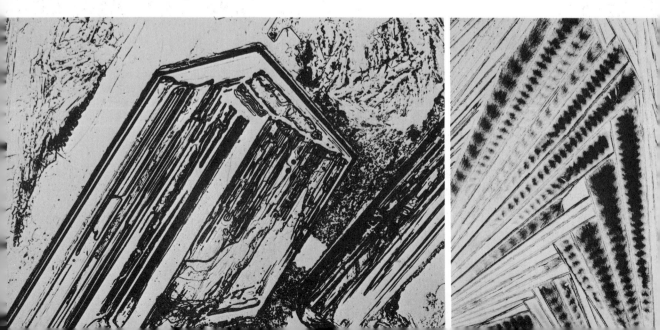

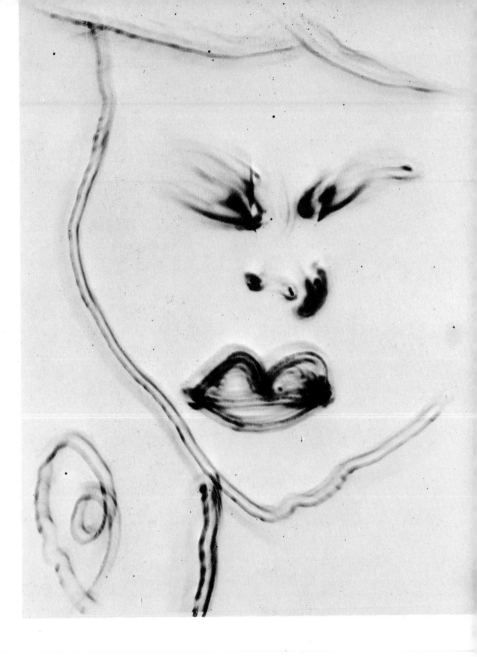

controlled light

It is possible to draw a picture with light and then develop the print rendering the exposed areas as black or grey against a white background. The window of a small torch or flashlight is covered with opaque adhesive tape and a small hole made in the centre.

This can be used as a light pencil, and provided it is held close to the paper a fairly well-defined line is produced. A few preliminary tests will show at what speed approximately you need to draw to obtain a good image.

Naturally, some artistic skill is an advantage for drawing with light, especially as you cannot see the lines you have just drawn.

For the picture opposite a few light pencil lines were drawn on the paper as a guide. If made too dark, they showed up as white lines on the print and had to be spotted out. But this method was essential unless the image was a very simple one. Some areas could be darkened by lines close together as in a pencil drawing. If the light was flashed, individual spots could be made.

Wind-blown sage brush from Nevada and Death Valley unquestionably made authentic looking 'trees' in the example on page 54. The tree and sand, gravel or torn paper were placed over a sheet of plain white paper. Four blocks were set beyond each corner with a sheet of glass resting on them. On this glass six pieces of torn paper were separately hinged. But the hinges for each were in the same position, so that they could be flapped back after each exposure.

The build-up started with the nearest hill and they were added one by one until reaching the 'mountain', which was last. The division of exposure time had to be worked out as best it could. In this case the sky was not to be a pure white, so eight or nine exposure counts was the probable maximum (if 10 3-second exposures at $f8$ on the test strip read a good black). Starting with two 3-second counts at first, the top flap was turned back. One count was given for the next, but this time each hill was slightly shaded with a piece of cardboard just as one dodges in printing. The foreground remained exposed. The foreground materials were then brushed off and print developed. After development a contact positive was made.

With my early photograms I started out by using sand, gravel and soil for the foreground and the built-up hills and mountains. It was a messy procedure and the materials had to be rearranged each time when doing the unsuccessful ones over again. Later, I found that no difference is discernible between this and torn paper. Also, at first I used the light from the enlarger with the red filter over it

and printing paper in place. More recently, I have made the set-ups on glass and have not used the filter. In this way the image and shadows can be clearly seen and easily built up. For a second, third and fourth build-up tier, in scenery for example where the picture calls for it, put four blocks beyond the outside corners of the paper and use a piece of plate glass for each tier of the build-up. When everything is in place turn off the enlarger and substitute a sheet of single weight enlarging paper for the other sheet. The mountains, hills and cut-outs can be hinged on the plate glass and flapped back one at a time after the exposures take place. This can serve as a working guide for all succeeding pictures of the type.

For the beater and egg picture opposite a bowl with water and egg whip was placed over a portion of single weight printing paper. The glass sheet method was used. Holes were cut the shape of the eggs in a piece of black paper. One egg was printed at a time, covering the others with cardboard. Each egg was printed by burning in for the highlights through a piece of cardboard with a smaller hole in it than the egg holes, jiggling it about all the time so that it would give no sharp edges. For the broken eggs a hinged flap covered one part while the rest was being exposed. The final exposure was for the whole negative, leaving the bowl and whip in place. A positive was then made.

54

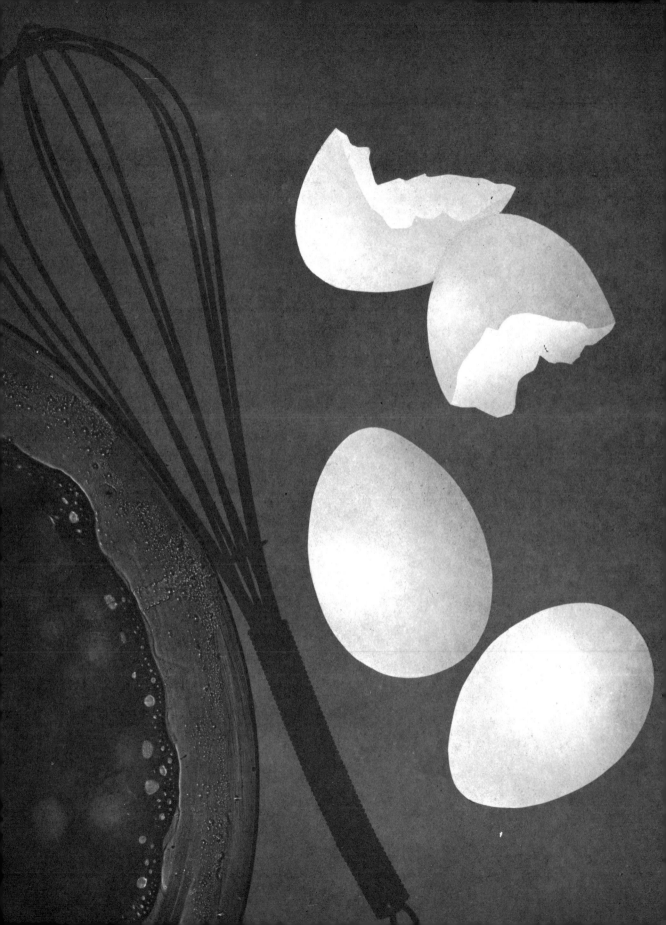

The bottle, knife and glass (bottom, left) is the result of a more complex process. The objects were laid on paper, a glass sheet was laid on blocks above with pieces of bread placed on it, and above this another sheet with a sheet of paper for the 'table'. Exposure started with the sun. First, a long exposure through a hole in cardboard was made. Then for the surrounding flare this was given about one 3-second exposure quickly raising the cardboard towards the lens. The flare on the table edge was done the same way only the cardboard for this was the piece cut away from the table and moved during exposure. The table was removed for an overall exposure. Then the bread came off and another exposure was made with the other objects still in place, then reversed.

Plants or weeds are interesting subjects for photograms but roots are especially good. The picture below (right) was made with roots from a fir tree that had blown over, laid on a glass above the printing paper. Cardboard with an uneven roundish opening was held in the light path and a dodger was held under the circle and moved around. The horizon was printed in by holding two straight pieces of cardboard parallel and moving them about. So a foot switch was almost a must. One feels in need of four or five hands when making prints of this nature. After an overall exposure it was reversed.

The strongly patterned photogram opposite was made with

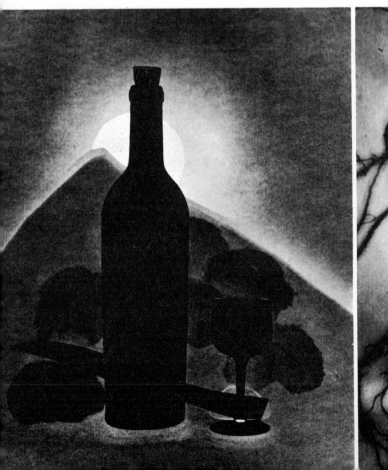

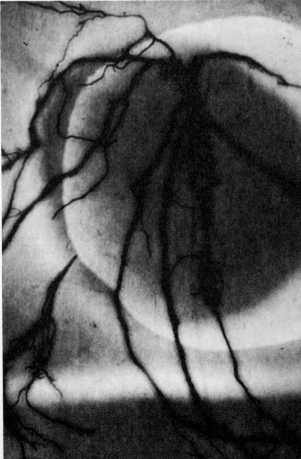

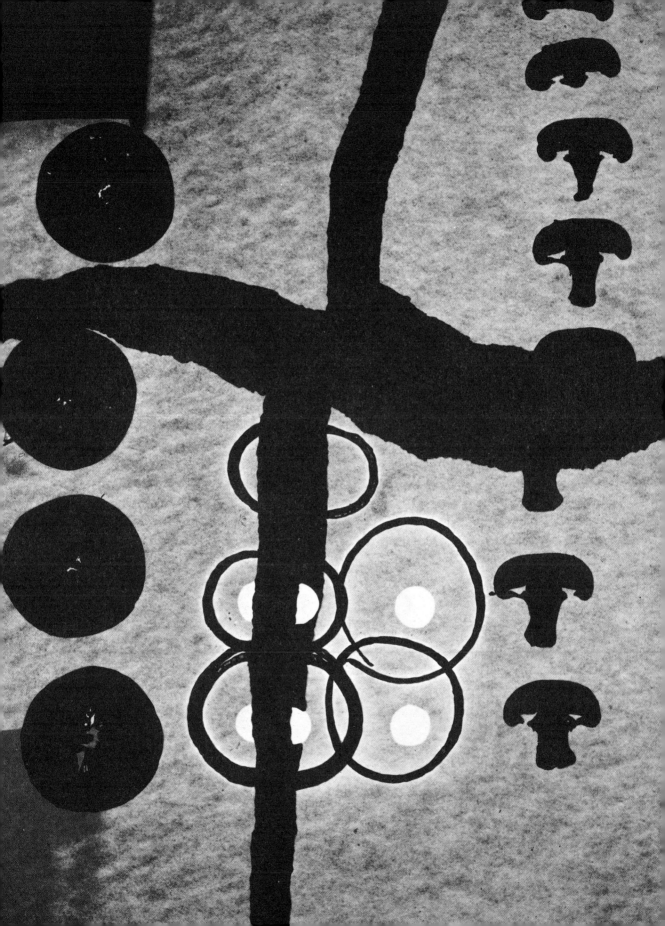

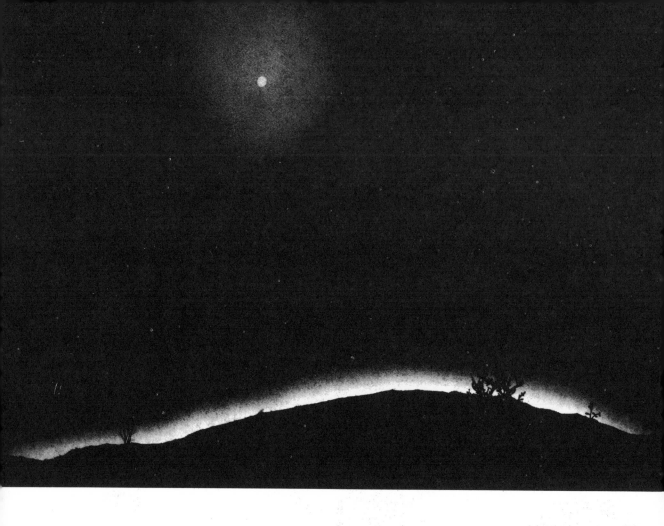

orange slices, onion rings and mushrooms laid on a glass with the printing paper underneath. The four white pieces were printed in first through a card. After an overall exposure was made and the print was developed and dried it was torn in pieces and laid on the new sheet of enlarging paper and printed.

This landscape used virtually the same technique as the preceding abstract. Torn paper was laid on the printing paper along with a few tiny shrubs. A small hole was cut in a piece of paper through which about nine counts of exposure were given for the moon, then one count for the surrounding halo, raising the paper all the while. Next a piece of paper cut to about the same shape as the hill was

58

moved about during the exposure. The resulting negative was then printed.

The photogram below partly originates from a camera negative, the negative image determining the outline for a cut-out. Pictures of oil-wells and refineries were first enlarged to about the size I wanted. They were then cut out and placed on a piece of single weight enlarging paper with torn paper and weed for a foreground. Four cut-outs were hinged on a sheet of glass on blocks above this. There were distant oil-wells, the refineries and the mountains. The total exposure was divided into five. Each exposure was shaded from the top then flapped back. This photogram representing a scene in California took 14 tries plus a positive print for checking each one. It added up to 28 prints in all but photograms are not always such a trial. Sometimes the first negative will be right.

The photogram on page 60 (top) though striking, was simple. Bleeding Heart plants were placed on the printing paper. A card cut to follow roughly the line of the flower was held over it and moved constantly during exposure. The print was reversed.

A different 'specie' of tree from Death Valley, along with a torn paper ground was the basis for the example below it. Each glass plate had to be high enough not to interfere with the trees beneath it. Three more tiers were used giving different exposures in all. This was reversed.

For the surrealist effect on page 61, an onion was laid on the paper. Cut paper 'mountains' were hinged at the horizon line on the usual block-mounted glass sheet laid above. Before starting the

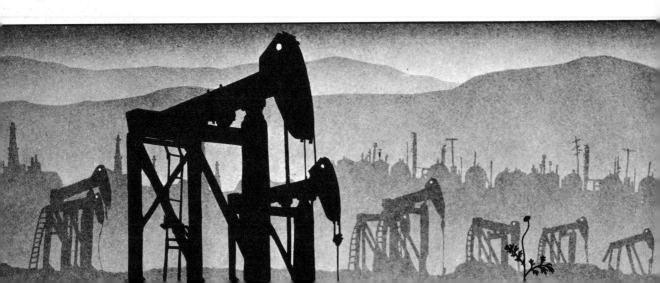

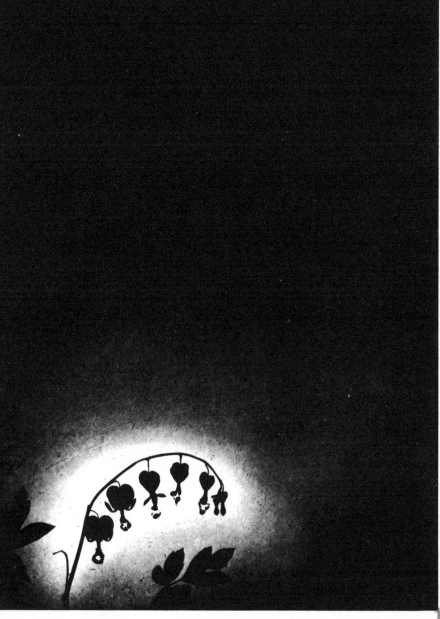

exposures, the bottom was covered with cardboard. Starting on the upper part, the moon was printed in through a round hole in a card and the sky was exposed for a portion of the total exposure required. Beginning with the most distant, the mountains were flapped over and exposed. A last exposure was given with all turned down. These were then removed and noting carefully the horizon line, a card was placed over the upper part. A piece of transparent Cellophane, with lines drawn in indian ink, was placed on the glass and exposed. The negative was developed and reversed to positive.

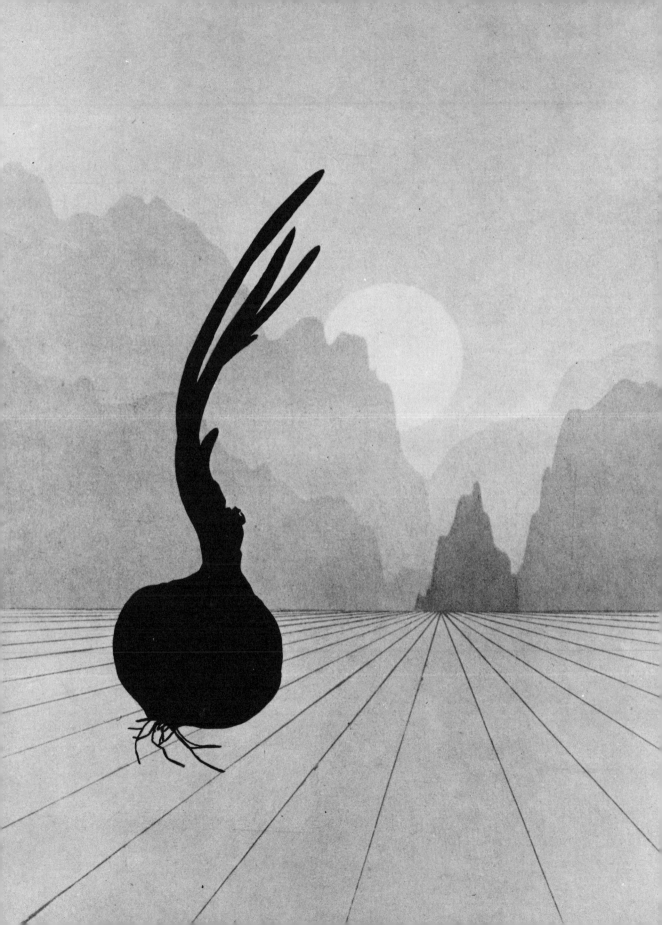

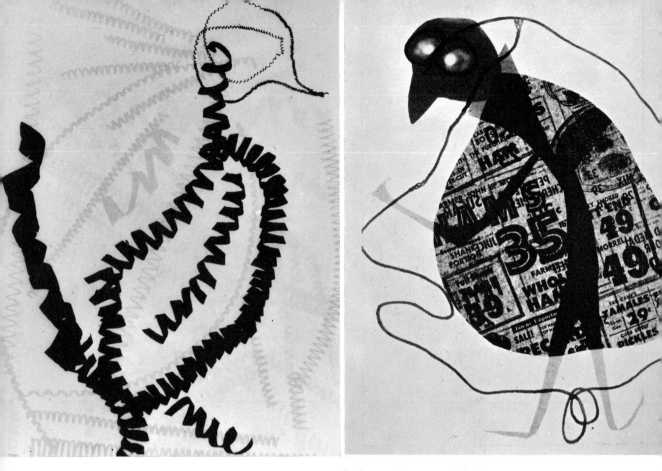

happenings and humour

Humour, always rather difficult to convey consciously in photography, finds a perfect means of expression in photograms which are not subject to the same limitations as the cold reality that must appear in front of the camera lens.

This fun picture (top, left) was made up from steel shavings. Three tiers of shavings were placed on glass plates, the resultant print was reversed to positive.

'Big Sale!!' (top, right) was built up to fit an idea. Newspaper, string and cut paper was used. Except for the eyes it was just one overall exposure. The eyes were burned in with a flashlamp. A positive was made from the negative print.

'Naida' in the tunnel effect picture (right) is a combination camera negative and photogram. She was printed in first through a paper covering the whole sheet, but cut out where the face would be. After exposure the piece that was cut from the sheet was placed exactly where the face had been and on top of this were several

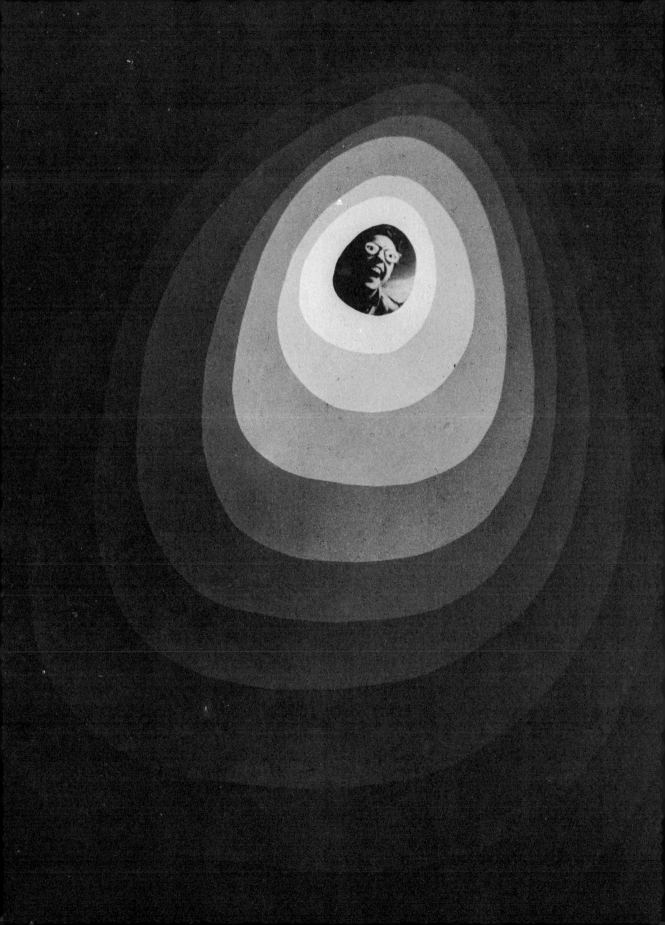

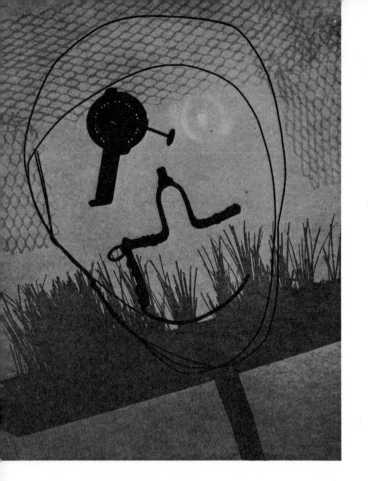

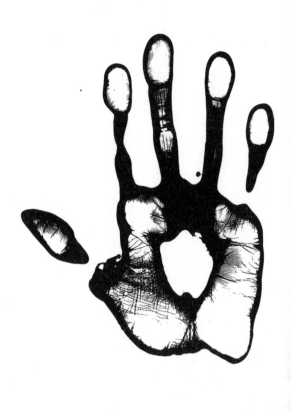

pieces of opaque paper. One was removed after each exposure. There was no reversal here, this is the final print.

'Charlie' (above, left) came from a Palm Springs garbage dump. The 'found' objects were placed on a single weight paper and exposed for nearly the full time. A lamp with its reflector in place, was brought into close contact with the paper, giving a white eye and surrounding circle. The negative was developed and a positive made.

When one makes an error it's fun to see what can be done (top, right) instead of condemning the paper to the waste bin. I realized the exposure was wrong so I flashed the whole paper with open light for several seconds, dipped my hand in the developer and held it on the paper for $1\frac{1}{2}$ minutes, then fixed and washed it.

The figures (right) were not made from pipe cleaners but ordinary twine. The twine was laid on double weight enlarging paper and manoeuvred into the shapes of a couple of figures. Above these, on a glass was placed a sheet of opaque paper with a couple of rectangles cut out. The basic exposure was the full amount necessary for a good black. The cut paper was removed and another quite **64**

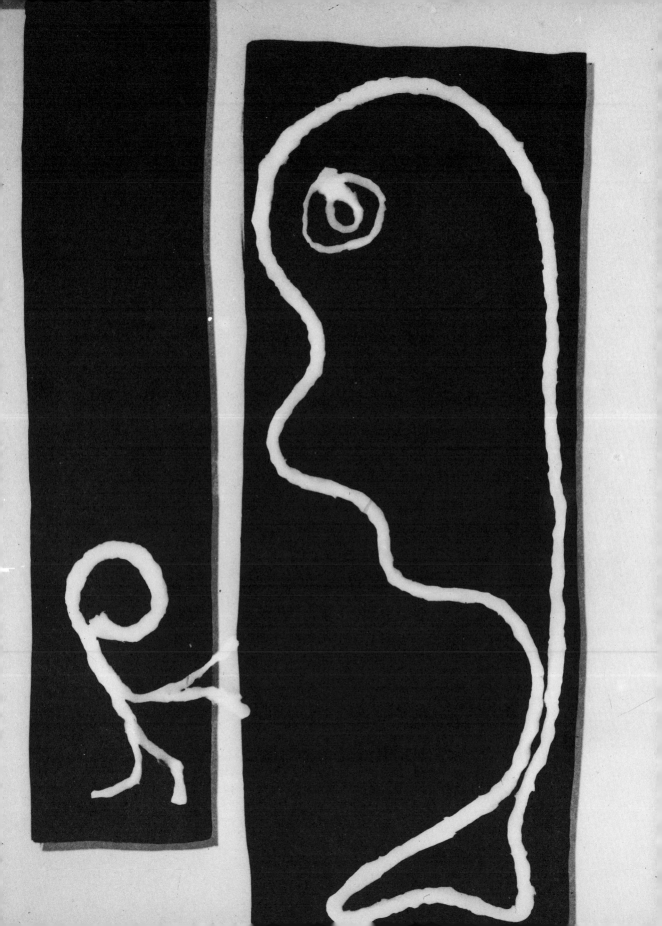

short exposure made. When developed, this was the finished print.

The babies' feet (below) were dipped in developer, then placed on pre-exposed printing paper. This was intended as an amusing record. It will be unbelievable in years to come when he's six foot two and wears size twelves!

While each print made this way is pretty simple in principle, don't expect the first one to turn out just as you want. In this case it took 24 tries to get what I wanted.

I thought this positive was fine—as far as it goes—as a record. One that any parent would treasure for a lifetime. But I decided to try for a picture that had more universal appeal—one going

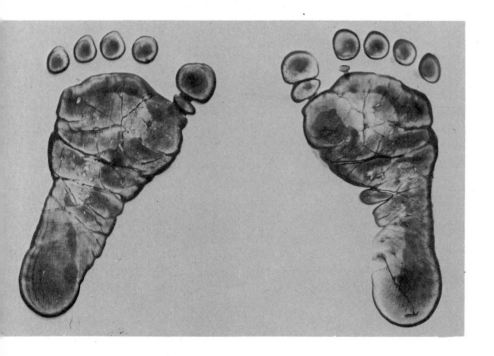

beyond a parent's interest. So I made a number of impressions to offer a choice. Some were smudged—some with good left while the right was not good, or vice versa. I made up three pairs that were acceptable. I cut out from a 16 x 20 card four roughly drawn round spaces that would cover the images. After making a test I placed the card on a 16 x 20 sheet of printing paper (positioned on the enlarging easel) covering three of the spaces while I placed one original print in contact on the open space and printed the usual way. When printed, I covered it up and uncovered the next one. I printed the next as before and went through this procedure four

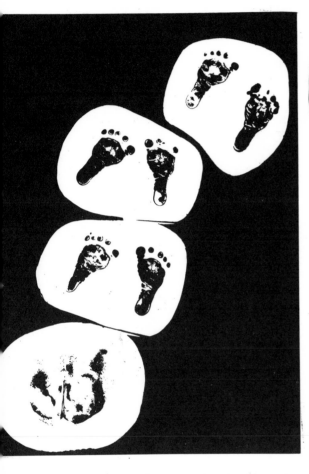
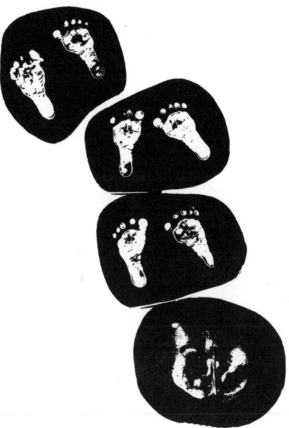

times. You'll have guessed what the fourth subject is. I then developed the result above left.

To make a positive I merely made a contact print of this 16 x 20 on to another sheet, above right. Sometimes it's hard to choose which is better, the negative or the positive.

Another way to use up old out-dated paper is to 'draw' on it.

Photography that can be done in the open light—anywhere—

would seem to be revolutionary. Actually, it's not. And it's very simple. Put some developer in a medicine dropper and draw with it on a piece of printing paper in the open light. Let it stand till the developer has darkened the paper as desired. This only takes a minute or so, then you put it in the hypo. The man (opposite) was made in this way.

The method is practically the same as drawing with a light source except for the difference in the tool used, and the necessity to do the light drawing in the dark-room and develop in the conventional

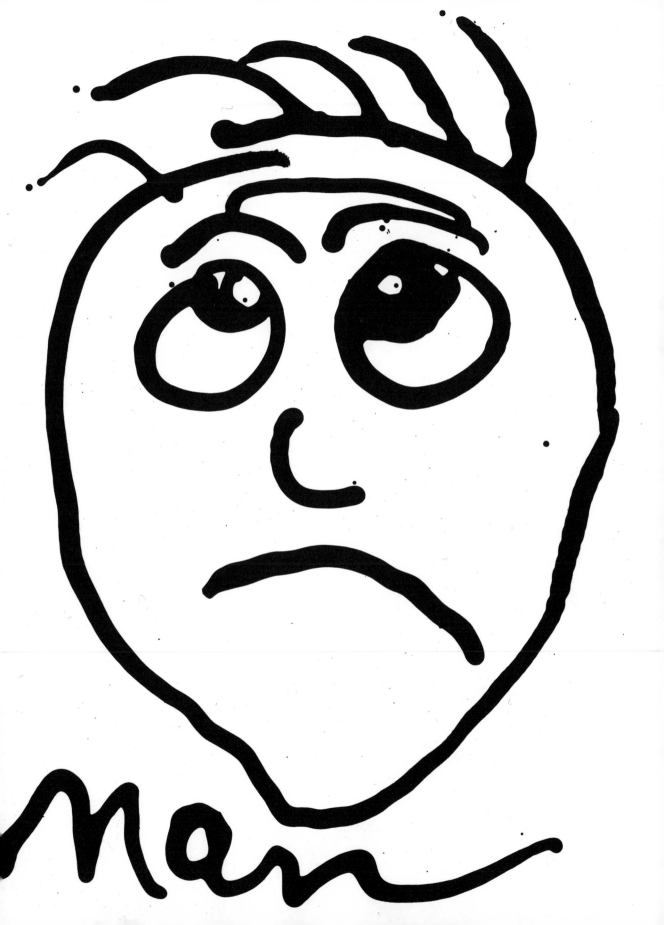

way. But this kind of drawing is not put in developer at all, only fixed after the developer has done its work.

The abstract below and that opposite did not require the use of 'solid' objects or materials at all. The patterns achieved may not resemble anything—or they may. But this is not the point, they have the peculiar beauty of those patterns which are a source of fascination from childhood onwards. They are permanent formations but resemble those shapes seen in oil on a wet road or the faces in the fire—things that one glimpses before they are gone, which one recalls but never records. This pattern was made by

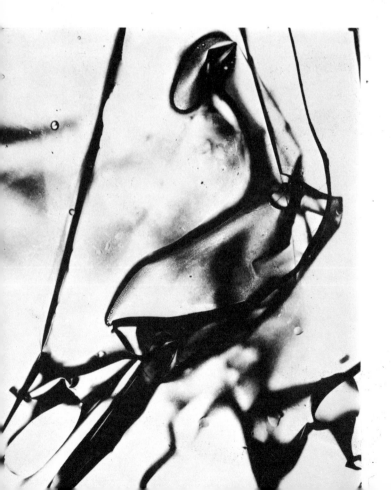

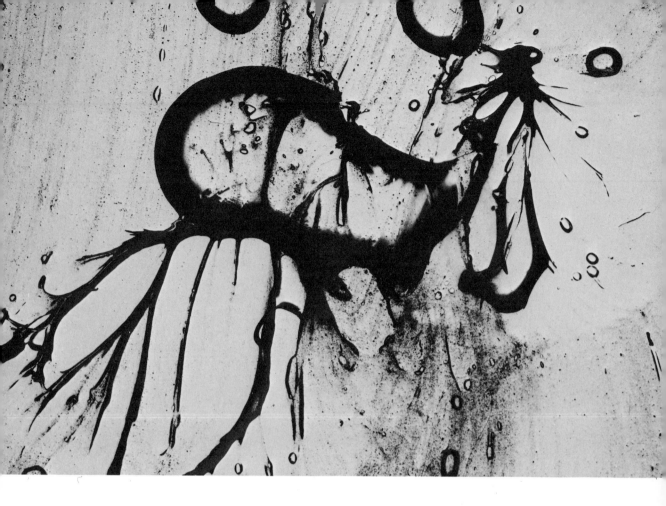

putting Cellophane and water in the enlarger carrier, exposing and developing the print which was then reversed to a positive from the negative.

The example above resulted from applying Vaseline and water smudged around on a piece of glass which was put in the negative carrier then exposed, developed and reversed.

Although simpler in many ways than the type of photogram where you work with objects on the enlarger baseboard, the results are far less easy to foresee, and offer virtually no scope for adjustment or alteration. If it doesn't work you just have to start again. It is more a question of knowing what to select rather than create.

71

cut-outs

Cut-out photograms can be made in the same way as ordinary paper cut-out pictures are. But this is not using the potential of the photographic process. In photograms the cut-outs can be varied in tone from area to area. These tones can be used to build up a picture, or they can be combined with silhouettes of objects placed on the paper, with the effects of putting translucent objects in the light beam, with local control of the light beam itself, or in combination with straight camera negatives. The scope for using cut-outs with other forms of photogram is enormous. But they themselves allow considerable artistic expression even without drawing ability. Naturally, for those who have some skill in cutting out designed shapes the possibilities are even greater. Those without can use basic geometrical shapes or a haphazard arrangement of odd shapes, cut out without any particular idea in mind. There are examples of both types on the following pages.

In the example, left, vitamin capsules were laid at random on single weight enlarging paper. On a sheet of glass above this were laid a couple of pieces of paper cut in a curve and slipped apart. This arrangement was exposed for nearly the full amount of time, then one piece was removed and a very short exposure made. The final print was a positive from the negative.

No negative was involved for the bird picture on page 81. The cut-out was placed on double weight enlarging paper and exposed for a full deep black. The large cut-out was removed and a rather short exposure given for the grey. The eye was the centre section

72

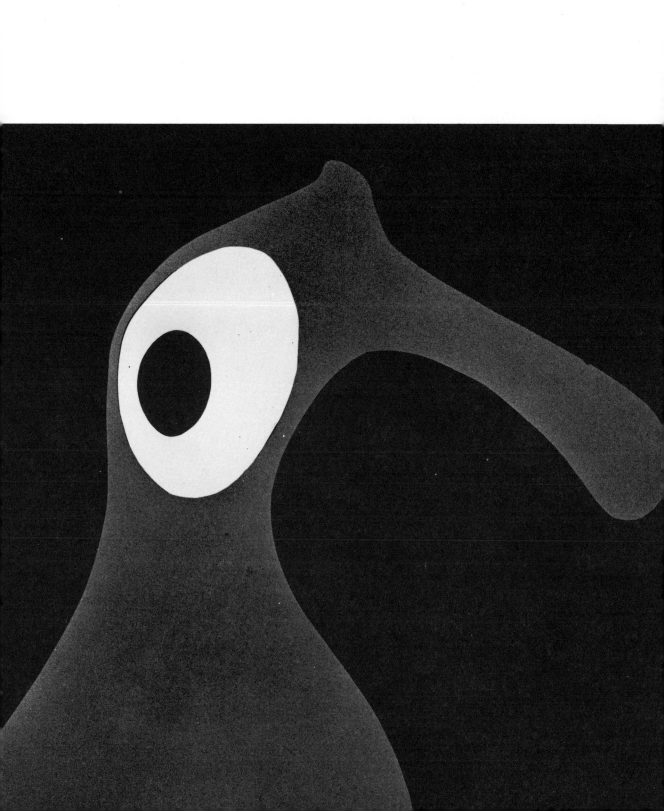

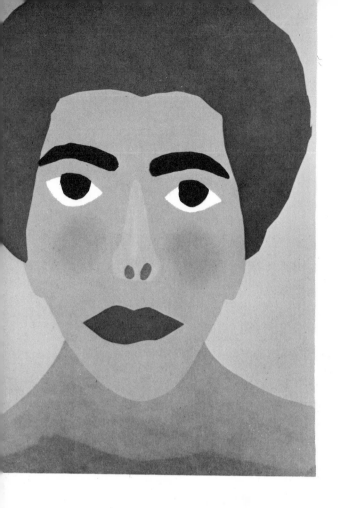

cut out of the head, with a hole made in the centre of it. This remained in position throughout the exposure.

For the face (above) cut-out eyes and mouth were laid on glass over a sheet of enlarging paper. The cut-outs were anchored down with tape so that they would not be disturbed when other pieces were removed during printing. Hair was cut. The face and nose were also put into position. The background and eyes were exposed first. The nose highlight was burned in, then the nose was printed, next the face, at the same time dodging in the cheeks—next the dress and finally the hair. The eye-balls, mouth and eyebrows stayed on the paper until all exposures were carried out. It was then reversed to positive.

A floral form (right) was made with one roundish piece of paper and the other cut in a spiral, like apple peeling. They were placed on a piece of single weight enlarging paper and exposed in two parts.

After the first exposure the round part was taken off. The print was reversed.

A one-stage photogram produces only one print. If more than one is wanted the whole set-up must be repeated. Any number of prints can be made from the negative of a photogram made in two stages.

Toadstools (below) were cut from black paper and a leaf from an iris was added. These were placed on double weight printing paper, exposed for a good black—and developed. This was the first and only print.

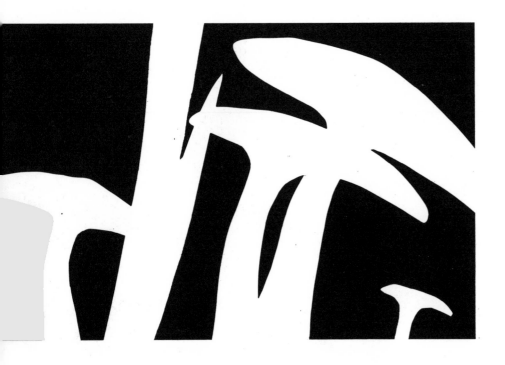

The type of 'photographic painting' shown right is about as perfect an example of actual light painting as one can get. It was made of cut-out pieces all lightly taped or hinged on a sheet of glass, set on single weight paper.

Each picture has its own specific problem that must be figured out. How and what and when to do what, and where and how long for each and every different tone or shape or shade must be thought out and tried. This example was so complex that it is difficult to remember or explain how it came about except that pieces were

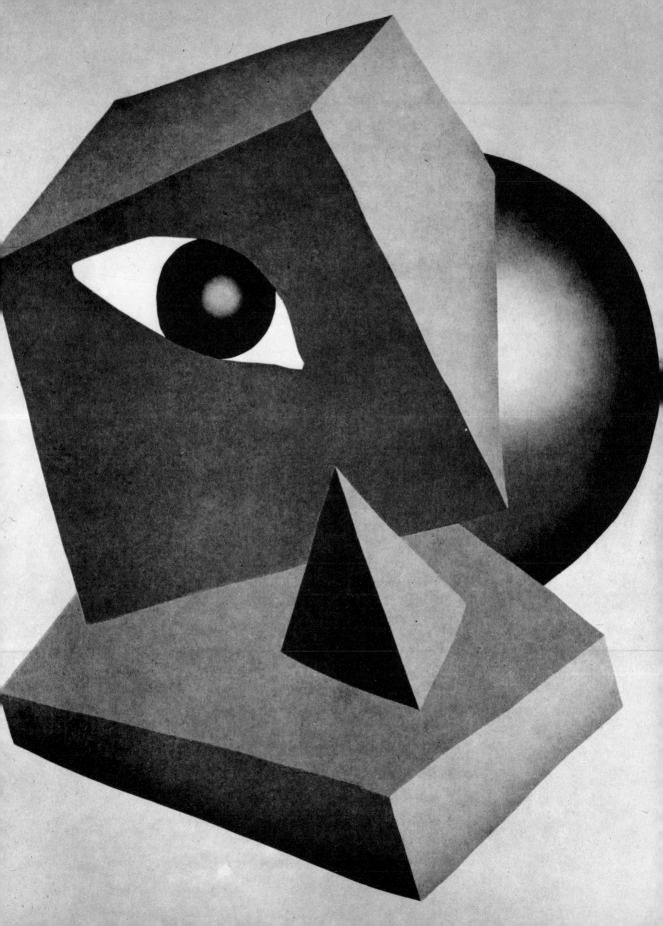

lifted up and exposed and put back and lifted up again, exposed and put back again, many times, and there was a small amount of printing in. It was a positive from the negative.

The background for the 'space equation' (below left) was cut and taped to a glass over the enlarging paper. The ball was cut away separately from the background and temporarily removed while through a hole in a card the roundness was burned in, then replaced. While exposing the scroll the shading was done with a card moving back and forth as it was being printed. When finished it was reversed.

This planet and its satellite, were prompted by an astronomy class. Two circles were cut out and placed on double weight paper. Another piece of paper, semi-circular, was laid over the circles and paper to make the foreground world from which the others are seen. The black was exposed fully—the large piece of paper removed and a short exposure was made for the grey, then it was developed.

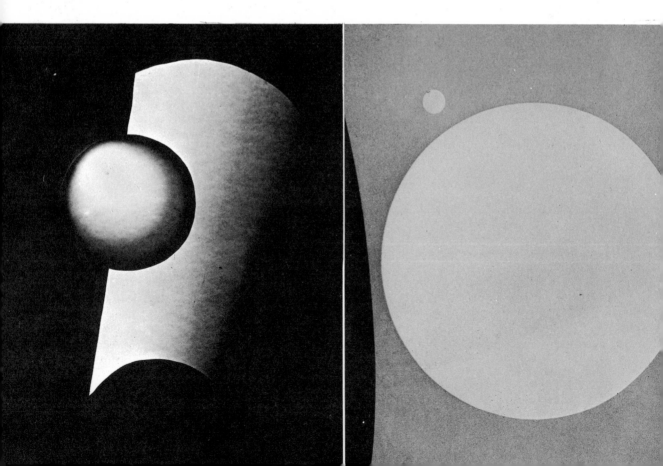

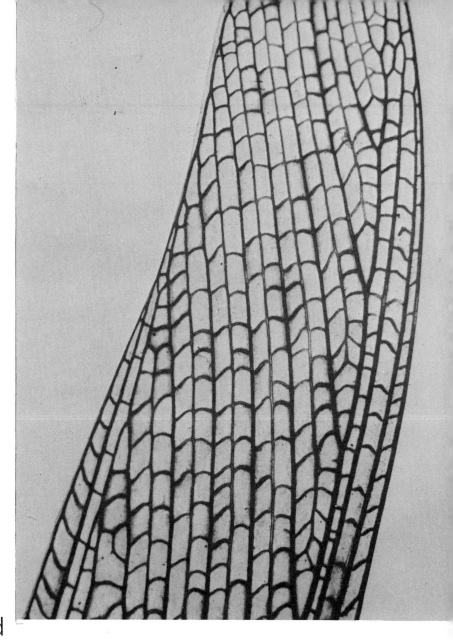

a small world

The remarkable detail of natural specimens when at great degrees of magnification, can to some extent be used in making photograms. Of course the enlarger cannot possibly approach the microscope in terms of optical power, but if you select the right subject the relatively moderate magnification can reveal patterns usable for photograms.

The wing of a grasshopper (above) was placed in the carrier,

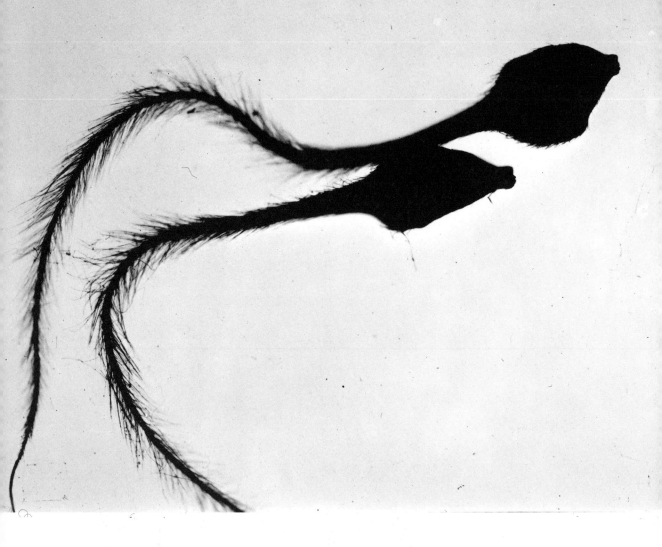

always sandwich between glass if possible, and enlarged on to single weight paper. A positive was then made.

At this degree of magnification one object can be used to represent another. The two above resemble minute organisms from a pond water sample seen through a microscope. In fact these swimmers are flower seeds, and were placed between glass in the enlarger carrier, enlarged, and made positive.

I noticed some grass with dried flies stuck to it in a friend's yard so with her permission I pulled it up and took it home. Some Cellophane, curled at the ends and filled with water, was also placed on a sheet of glass on single weight paper and a full exposure given. A positive made from the negative gave the result on the right.

The praying mantis wing (page 82) was made the same way as the grasshopper wing on page 79, so was the feather (page 83).

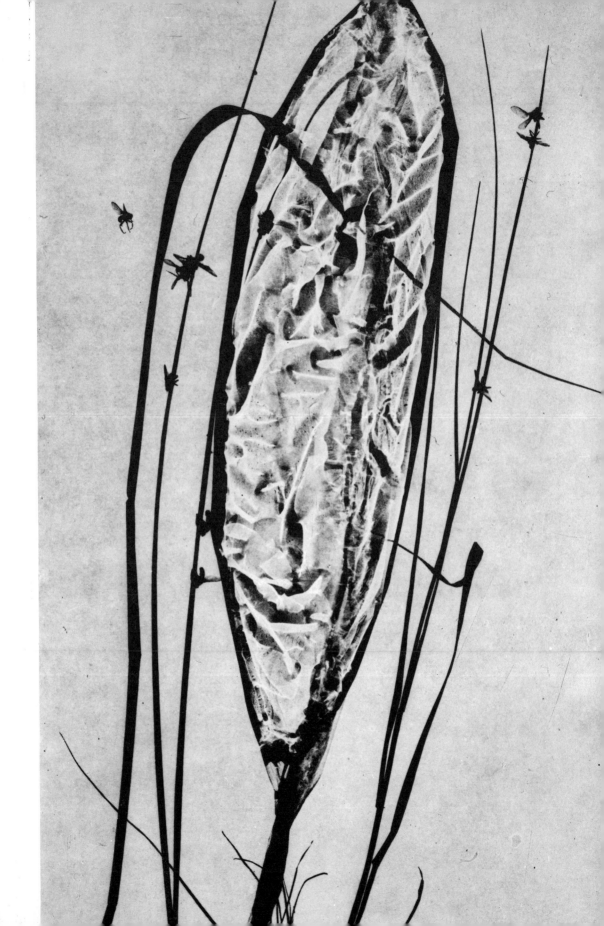

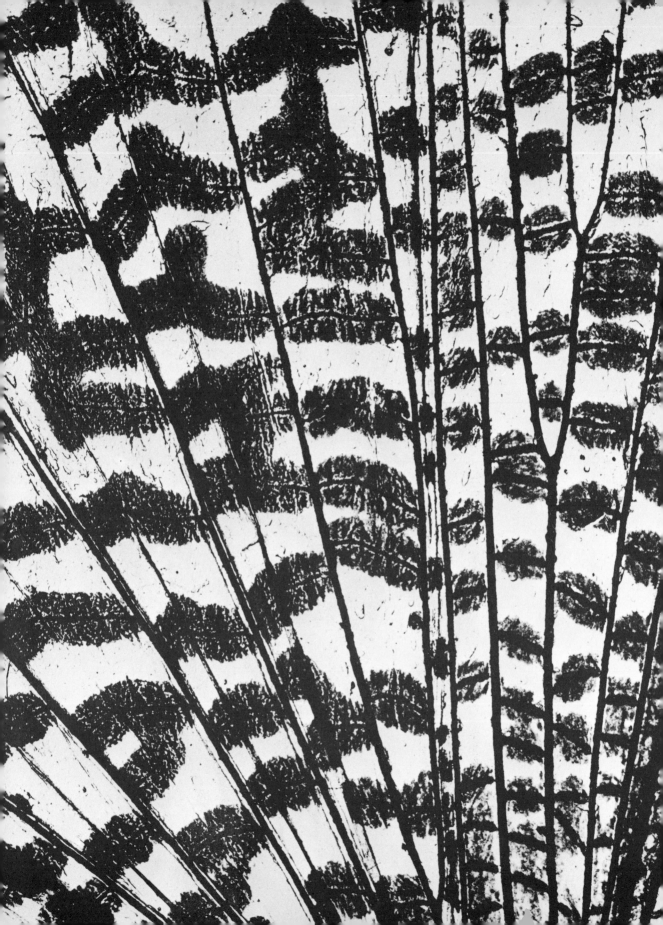

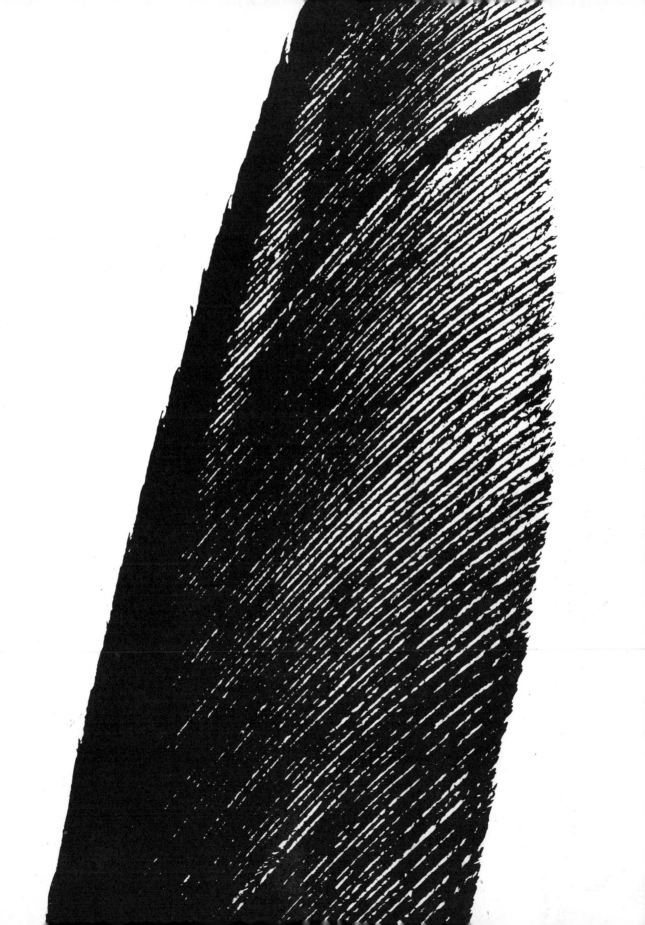

Sometimes the maximum degree of magnification is essential for a satisfactory picture from a minute subject. Here (left) the 75mm lens was changed for a 50mm. The gnat's wing was placed in the carrier and enlarged to the fullest. I have had the easel board on my enlarger made so that I can lower it to any level from the normal to the floor. In this case the printing paper was on the floor while the enlarger head was at its maximum height.

The yellow jacket's wing (opposite, left) and the fly wing (opposite, right) were produced in the same way, and are reversed.

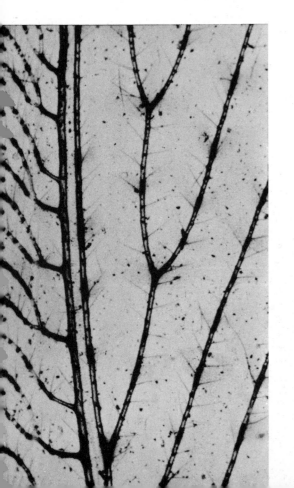

The edge of a bumblebee's wing above was made in the same way as the picture on page 84, using the 50mm lens, the standard focal length used for 35mm enlarging. A similar gigantic enlargement ratio was needed for the bug's inner wing below.

These two pictures make a good comparison of the extremes of acceptable print quality you must expect when enlarging to these dimensions. The enlarged section shown is of course only a fraction of the total projected image in each case. The baseboard can be

moved about to find an attractive composition, and the highly magnified subject offers more scope for this than any other.

A grasshopper's wing was the subject of the photogram above. Grasshopper wings are interesting, they have two on each side with quite different patterns. They make a very well-defined image and are nearly ideal for the purpose, and it should always be possible

to obtain a good clean bright image. Several kinds of insect wings will give such results and it is well worth searching them out for the purpose. The photogram was made in the same way as that on page 79.

One day I came home from a vacation and found a bug of some sort in the hypo tray. There must be an affinity between bugs and hypo! I'll never know why I left the hypo in a tray (unless it was to catch this bug). I put him in the enlarger and made a huge negative image of him on a 16 x 20 sheet of paper. I then made a positive print from it.

The print lay around for some time and finally I put it away with other discarded prints. It was just a record, uninteresting from a pictorial viewpoint.

Going over these one day an idea struck me that I could cut the negative up into strips, slip them sideways and then make a print from that.

I cut up the negative which was on single weight paper, and placed the pieces on top of a sheet of double weight. Pressure was maintained by a sheet of heavy glass, weighted down at the sides.

This second version opposite of my 'Hypo Bug' is quite acceptable and can hang on a wall as an attractive and interesting picture.

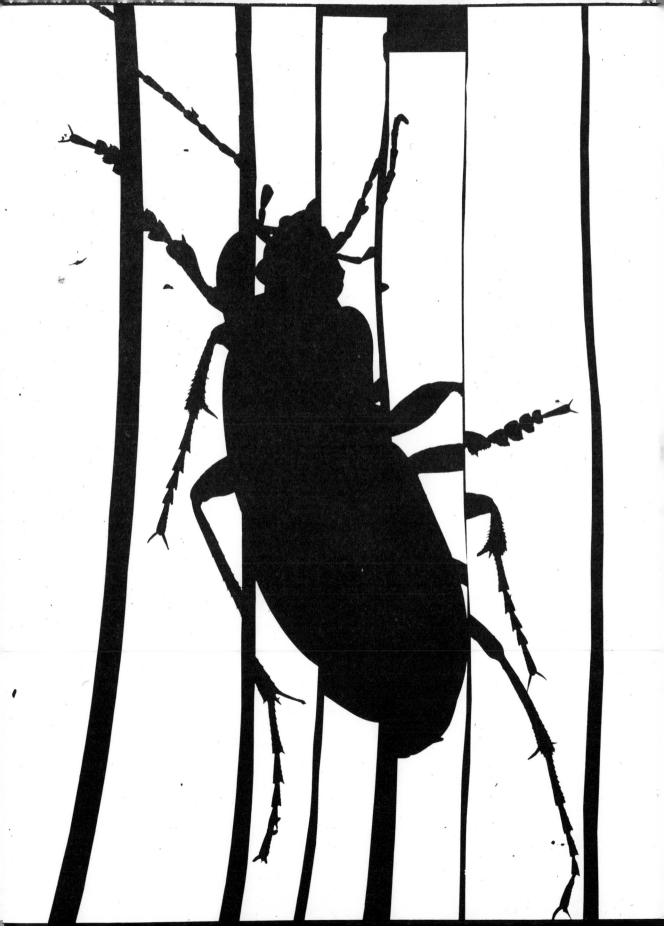

fish themes

Fish provide good subject matter for photograms, both fish bones and fish 'in the solid'. Backgrounds can be worked up with plant forms, rocks and other articles and different exposures given to these effectively represents the murky distance of an underwater picture. Fish bones can be made to 'swim' along with the others.

The 'Dragon Fish' (left) is a collection of fish bones placed on the paper. Above this on four blocks is a sheet of glass holding the roots. The single weight textured paper was exposed for about three-quarters of the total time, then the roots were removed and another short exposure made. When this was developed and dried, the positive was made, the paper surface increasing the effect of texture considerably.

The fish below were made the same way except there were more tones (four instead of two) and more levels to build up.

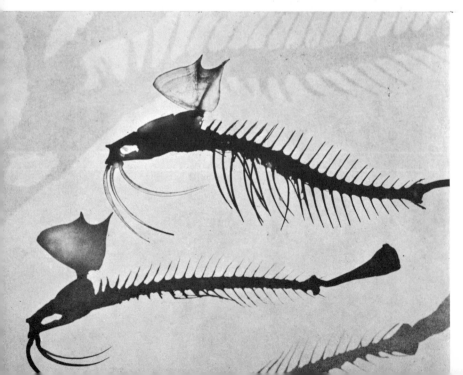

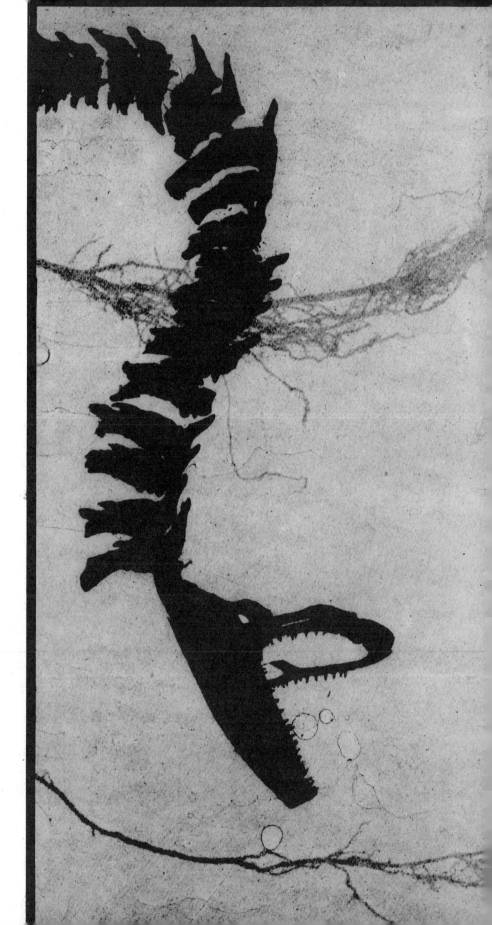

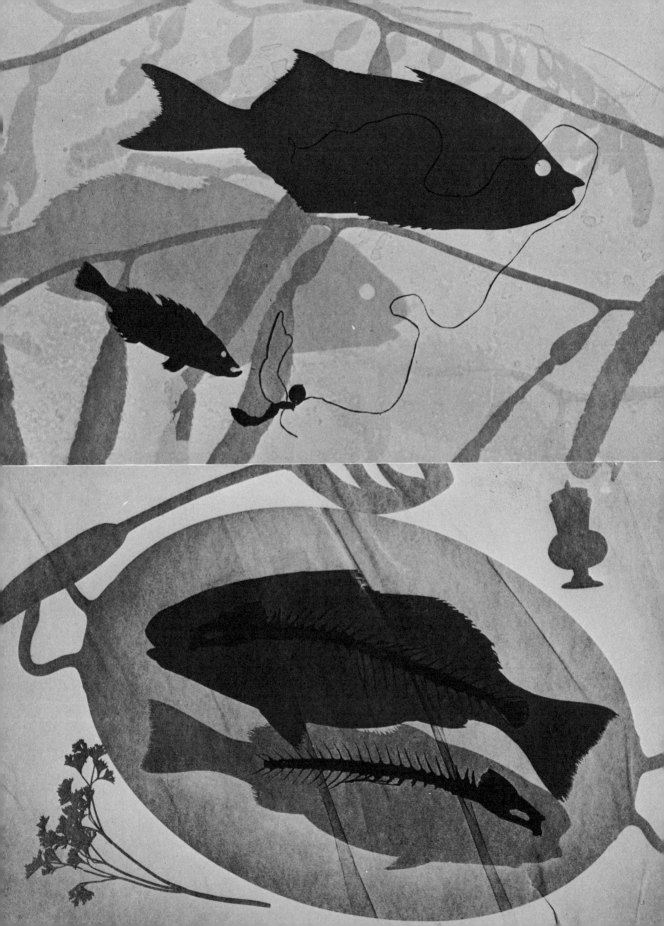

In the underwater scene (top left) some of the fish were cut-outs but the sea-weed was real and wet, the wetness adding a great deal to the watery impression of the photogram. The total exposure was divided into about five tones. Remaining stages were similar to those used in the picture on page 91.

The 'platter of fish' (left, bottom) was rather tricky to expose. I wanted the outside edges darker than the middle. To do this the outside would have to be held back slightly during printing by dodging, or the basic exposure reduced and the centre area burnt in. An oval cut in a piece of card seemed the answer and it worked. The negative was reversed.

I keep beetles to strip fish for the skeletons. They leave the skeletons intact which would be difficult to do yourself. This simple arrangement (below) made in two exposures for the negative print was afterwards reversed.

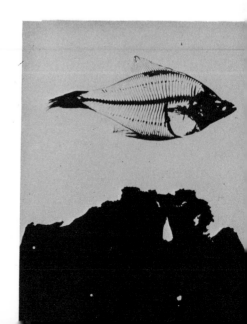

stories

The dramatic possibilities of photograms make them particularly suitable for creating near realistic set pieces which may themselves tell a story, or at least, can be used to illustrate one.

The photogram can be a combination of camera negative and cut-out or purely a cut-out from a print made from a negative in the usual way. Either way a degree of realism is brought into the picture, and this can give them a more disturbing effect. Controlled light may play a very important role here. Natural sky effects where the sky brightens towards the horizon, spot printed moons and suns and darkened foregrounds accentuate the sinister aspects of a dusk or night-time scene.

Where you are representing a real scene, precise control with light is far more important. With an abstract photogram, who is to say that this should have been brighter and that darker? But with story pictures, the more realistic the effect the more convincing the picture, so you have to follow certain natural laws. Scale must be more or less correct, objects must appear to be really in the scene not stuck on afterwards. The sky light must come from the right place, distant parts should be less distinct under certain kinds of lighting. Composition is as important as with landscape photography. Distant trees naturally look smaller and should not line the horizon only. It is often the middle distance that gives the effect of depth in a picture. All these things must be worked at and if there is something wrong look again, or show the result to someone and ask their opinion if you cannot see it yourself.

The bird in the picture opposite was cut out of black paper. Sticks and twigs were arranged in a couple of set-up tiers. For the moon a hole was cut in a card. The moon took about three counts, the halo round the moon one, and the background one. The distant twigs were then taken off and another count of one given; reversed from the negative. The rain in the picture on page 96 is dust and water between two sheets of glass pressed tightly together then slipped sideways.

A tree from Death Valley, U.S.A., served perfectly for the three levels of trees. Shrubs and rising ground were build-ups. Shading was carried out as each exposure took place. Both these pictures used the process devised for the example on page 54.

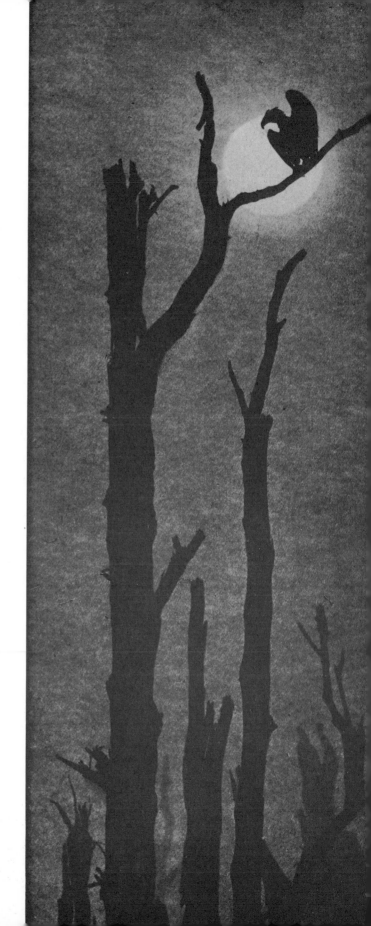

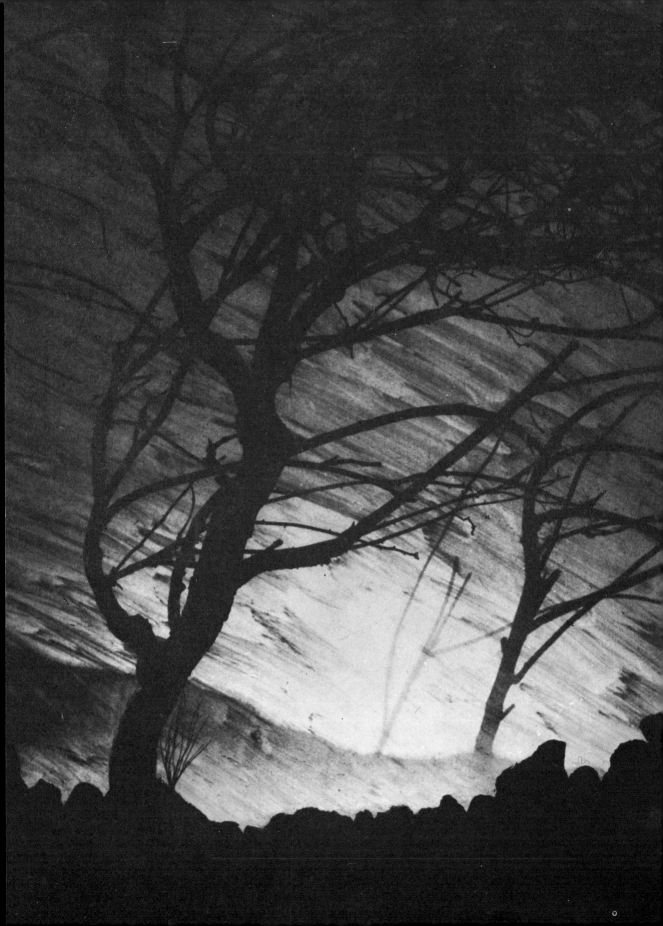

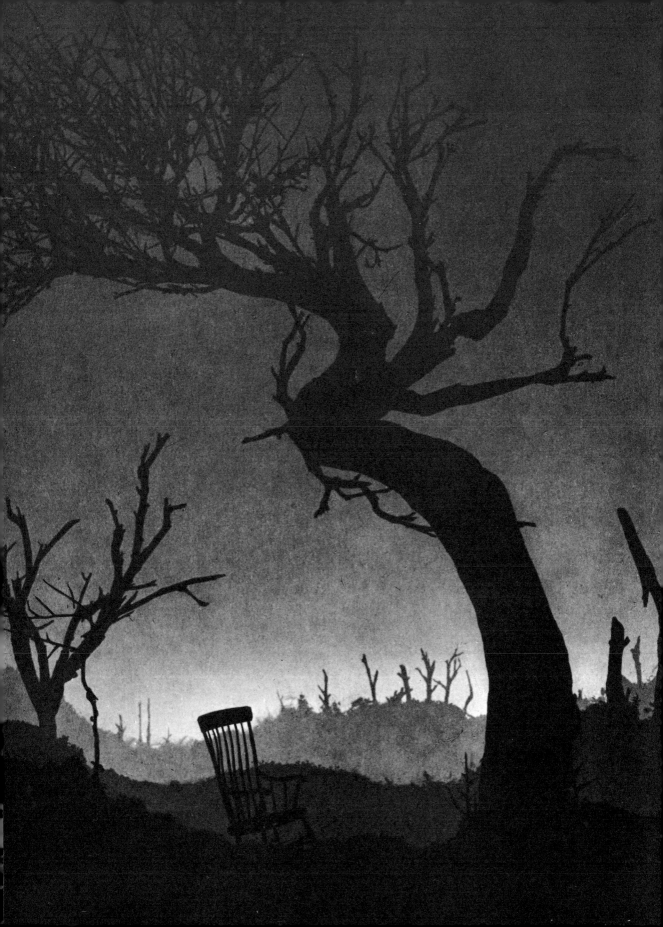

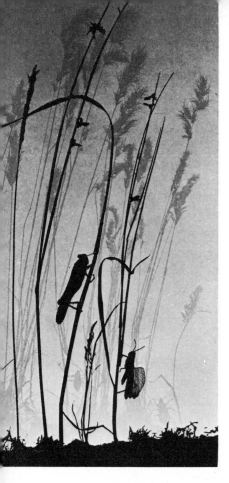

'The Inhabitants' (above, left) is quite a simple photogram, although it took five or six attempts to get the shading in the sky quite right. The layered glass technique was used here giving two main tones, but the slight burning-in at the bottom separates these tones more than if it had been a straight two-level printing.

Entering the world of the supernatural 'Tomorrow's World' (right) was a very difficult photogram to do. The relationship of light, distant land, sky and upper part, etc., is always a problem. The murky sky or 'rain' was set up like the example on page 96. The dead bird was found in my back yard. The mouse was given to me by some friends, who found it between an old wall and some woodwork, stiff and completely dried. The toadstools were also donated by some good friends. One might almost say it was a community project. The printing method was similar to that used for the picture on page 97.

The eclipse (page 100), though it looks simple was, with one exception, the most difficult photogram to do. I wanted a roundish sun, some flare from it, lighter rays coming down to earth, a slight halo round the earth and a horizon. First a round piece of paper was laid on the enlarging paper for the sun. A very light line was needed here and there to show where it was to go. This was taken off and through a hole in a card the roundness was burnt in. The card sun was put back. Next, an uneven piece was cut out of another card and the sun flare was burnt in with the card being lowered and raised and moved about quickly all the time. Next, the rays from sun to earth were burned in, holding two straight-edged cards at two angles. The horizon was last. It took 34 tries and almost as many prints in checking them. This and 'Tomorrow's World', another one exceeding this in number, sounds fantastic but I don't know of any other way than to just keep on trying.

The example on page 101 was a build-up of four tiers. It turned out to be difficult to get the lighting properly balanced. The right

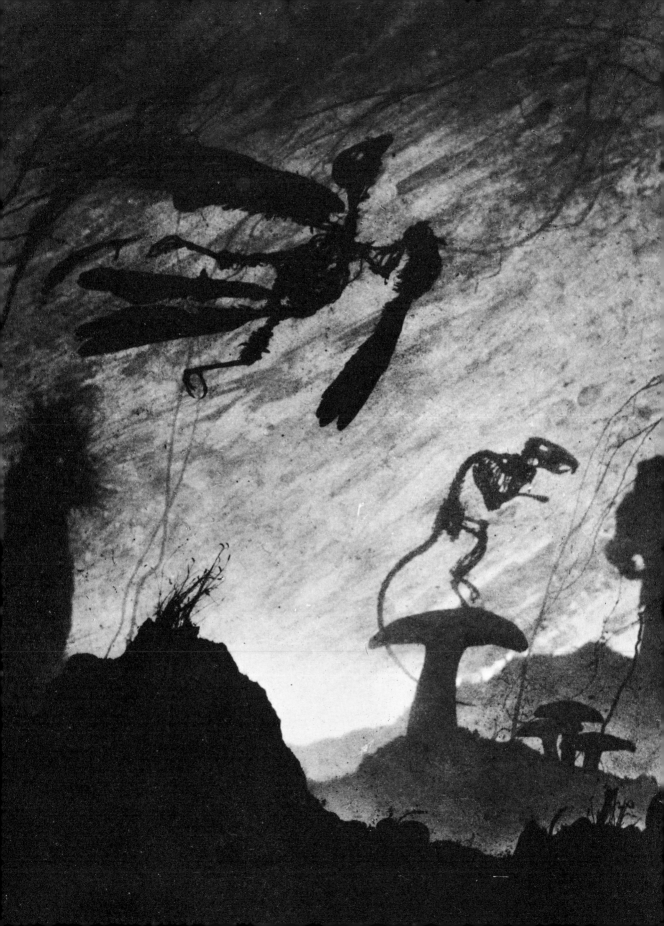

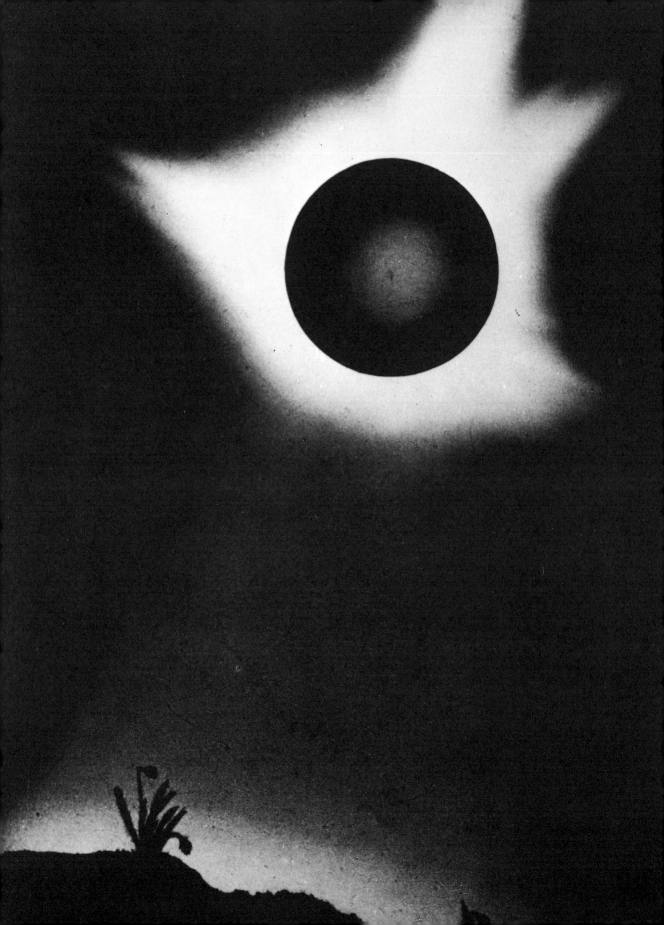

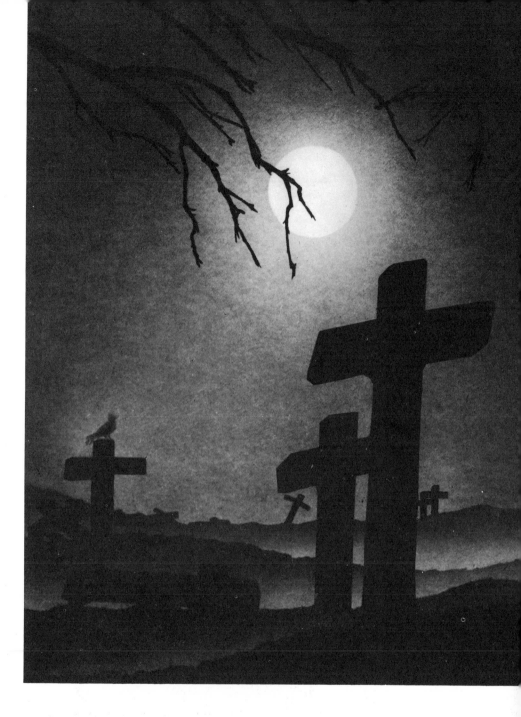

amount of moonshine, the right amount of flare, and a dark sky was a bit of a job to achieve. After several tries it came out satisfactorily. Technical data is similar to that for the picture on page 54.

Using as a theme the style of oriental characters, 'Peace on Earth' (page 102) is a combination of camera negative and sheet of glass painted with acrylic black, reversed to positive. This was a quite straightforward job.

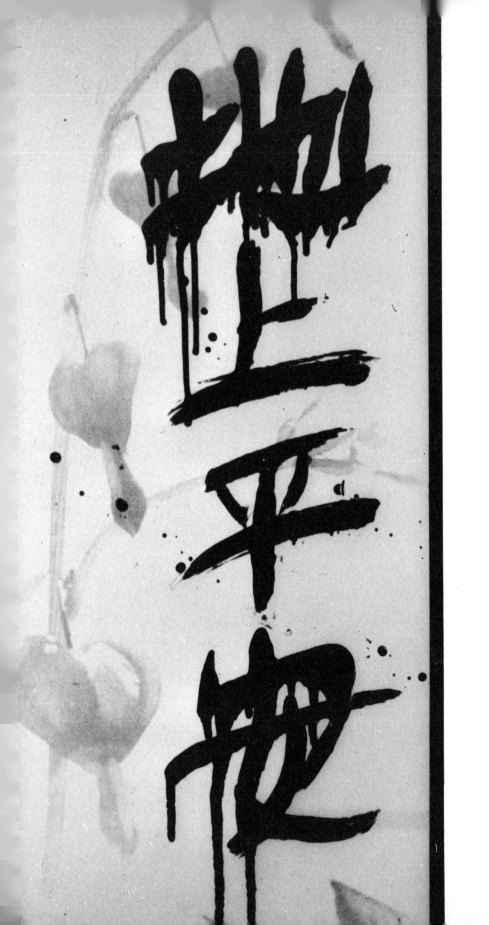

102

solarization

The process used for these two examples is *paper* solarization as opposed to film solarization. The process takes place on the paper print and a camera is not involved at any stage.

For the first picture (page 104) daisies were laid on a sheet of single weight enlarging paper and exposed for the full time necessary to print a good black. About half, or three-quarters, of the way through development of the print it was withdrawn from the dish, placed on a sheet of glass and the solution swabbed off. The print was then exposed to white light for a very short period.

The exposure time given with this technique depends upon how close the light is to the print and the wattage of the bulb, and also, to some extent, how long the print has already been in the developer.

After exposure it was returned to the developer and left there for the remaining period making up the full development time. The resultant negative was quite black but with thin white lines around the image. The positive was a reverse of this giving black lines on white.

The teasel on page 105 was made in the same way.

DARKROOM TECHNIQUES FOR MAKING PHOTOGRAMS

There are several reasons why anyone attempting photograms should have a thorough grasp of the techniques they will need to use. Those who believe they need elaborate equipment may have their fears dispelled; there are many kinds of photogram which can be done with scarcely any equipment at all, and certainly far less than you need for ordinary photography. People already owning equipment and those proficient in straightforward printing should know how to apply it to the present purpose, and how to achieve results of the best quality. Although a photogram is often a simple arrangement of lines and tone areas, there is certainly no less need to obtain good quality than with an ordinary print. Unsharpness, unevenness of tone, accidental movement or poor print quality are all just as obvious and, whereas slight unsharpness may not matter too much in a candid shot taken in the street, it can spoil a photogram.

With an understanding of, and some practice in, the various techniques to be described, they may be combined and the more complex sort of photogram produced without too much experiment. Experiment is interesting as long as there is discovery waiting at the other end. But failure to get this or that effect because of lack of practice turns the whole process into a tedious chore. It stands to reason that, with a photogram needing say three techniques, if one keeps going wrong the other two have to be repeated at every attempt, and that can be expensive. Plenty of groundwork, then, always pays dividends and even the simplest photogram should be a good one.

light sources

The enlarger is the traditional light source for making photograms. This is largely because most people investigate photograms after doing more conventional forms of photography. An enlarger is certainly a very convenient tool for the job and offers greater scope for creativeness than other light sources. If you wish to make a large number of photograms or explore their possibilities to the full and you don't already have an enlarger then you should either

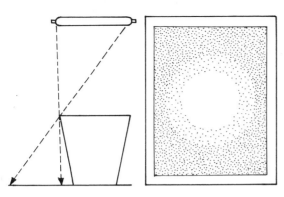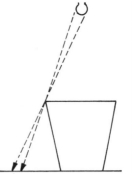

Large sources give diffused shadows, smaller sources sharper ones.

invest in one or try to borrow one somehow. You can, however, make do with other light sources, which produce photograms different from those made with an enlarger.

To make a straightforward photogram the most desirable light source to obtain sharp shadows is a highly directional one, though this is not important if the objects placed on the paper have no thickness and are in perfect contact with the paper surface. Where the objects do have thickness, and therefore partially stand clear of the paper, non-directional light will tend to creep round the edges. The outlines of the shadows therefore tend to become rather ill-defined.

Where the objects are mounted on glass sheets such as some of those in this book, directional illumination is of even greater importance. Generally speaking, the further the object is from the paper surface the more difficult it is to obtain a sharply defined silhouette. When there are several layers of subject matter it is very difficult to render them all sharp. One usually aims to get as hard edged an image as possible.

The best ways to obtain directional lighting are with: (1) the enlarger, with the lens focused on the baseboard and a small aperture setting; (2) a baby spotlight or domestic or display spot-lamp far enough away to cover the whole area of the paper evenly or (3) a small domestic lamp (i.e. an ordinary tungsten house light) shining from a great distance.

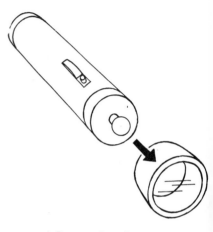

Remove the reflector.

If a lamp is used the smaller the bulb the better. If it is a torch bulb, remove the reflector. A domestic bulb should be preferably the low power type with a small diffused (not clear) envelope. The baby spotlight may prove too powerful for use with bromide paper, giving exposures too short to control. If it is adjustable it should be set at the position giving the smallest spot of light. It will then be most concentrated and give the sharpest edged shadows. A domestic spotlamp has a wider spread of light and its power can be reduced by cutting out a black paper mask with a central hole and fitting it in front.

This could be done with any domestic lamp to prevent the light from spreading around the room, and to reduce the power of the lamp and will work equally well with other types of light source.

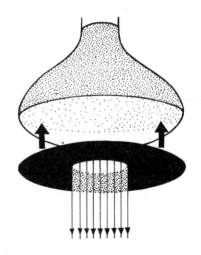

Mask a spotlamp.

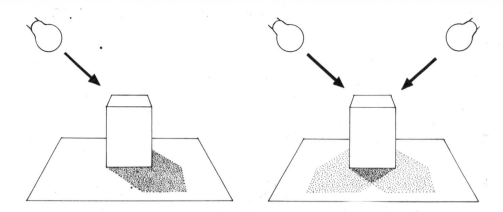

One lamp gives one shadow, two lamps give cross shadows.

lamps

The lighting for a photogram should normally be quite even. So whatever kind of lamp you choose its illumination must fall evenly over the whole area of the paper. There must not be a 'hot' spot in the centre or any darkening towards the corners. With a naked bulb a hot spot usually means that the bulb is too close. A spotlight may need adjustment to widen its beam and reduce the power. Many domestic or display spots can be adjusted.

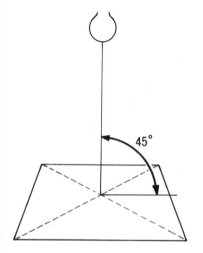

The lamp at right angles.

Normally, the light source must be at right angles to the paper surface and placed centrally. An advantage that a lamp has over an enlarger is that you can angle it to the paper and throw elongated shadows from any solid objects placed on the paper or above it on glass sheets. More than one light can give cross shadows, or many lights, multiple shadows. A light can be deliberately moved during exposure to give a diffused shadow with no definite outline.

Naturally where lights are angled to the paper you cannot expect perfectly even illumination. But if the lamp is far enough away the difference would not be noticeable.

Opaque adhesive tape can be placed over a torch or flashlight leaving only a small hole for the light to come through. You can then draw on the paper with this 'light pencil'.

enlarger

The enlarger is a fixed light source, has a limited adjustment for distance and cannot be moved about. Nevertheless the light from it can be made directional or diffused and as even or uneven as you wish. With an enlarger it is easier to carry out local print control, dodging (shading-off and printing-in). Moreover its original purpose can be applied to photograms, where the specimen is placed in the carrier and projected on to the paper like a negative. This projection capability cannot be matched by any technique with other light sources. Thus, the enlarger is supreme.

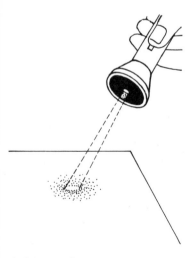

A light pencil.

Enlargers are really more suitable for direct rather than angled lighting. Even if the enlarger head can be swivelled and the photogram set up off the baseboard, or the baseboard tilted on the lens **108**

axis, uneven illumination is far more of a problem than it is with an ordinary lamp used at a distance. With an enlarger, the print would have to be specially shaded off towards one edge to even out the exposure. This would mean quite a complicated operation for every photogram. Objects on a tilted baseboard would somehow have to stay in position. This is virtually impossible. Only flat objects can be held down under glass and they cast no shadows, anyway. The baseboard could conceivably be inclined beneath a block-mounted glass sheet with the objects placed on it but, even so, baseboard tilting is limited to four fixed directions which make it scarcely worthwhile.

setting up

The enlarger should be set up in a place giving clear access all round the baseboard and some clear surfaces at either side. Between exposures objects used for the photograms must be disposed of or replaced again without trouble. When projecting objects placed in the negative carrier, lengthy exposures are often required so there must be no vibration, for example from passing traffic. The baseboard must be rock steady so that if an object is removed between exposures nothing will shift. A foot switch leaves the hands free for other work.

Any kind of enlarger will do. The usual precautions about stray light from the lamphouse apply fully here because fogging may be noticeable on some kinds of photogram, and one has enough difficulties in any case trying to achieve clear highlights. Keep the carrier in position even if you are not using it. It prevents stray light being thrown around the room and also masks the light down to a convenient rectangle. Remove the glasses, they collect dust.

checking and adjusting the illumination

Use the longest focal length enlarger lens if you have a choice, keeping the light beam to the minimum spread. But it is really more important to have even illumination. Put a negative in the carrier, switch on and focus on the baseboard. Take the negative out and put a sheet of plain paper the same size as the enlarging

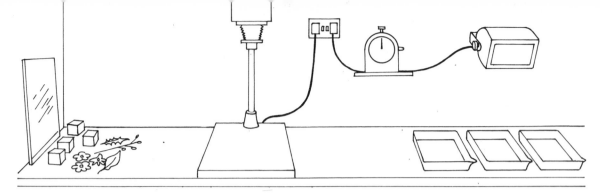

Arrange objects in the best places on either side of the enlarger.

paper you intend to use on the baseboard. Examine this carefully, checking that the illumination is even all over. If it is not, move the enlarger head farther up its column, re-focus and check again. Failing this, try another lens. Sometimes you get more even lighting if the lens aperture is closed down slightly, but the above test and focusing should be done at full aperture—you may need to work at this setting, or near it.

For normal photograms the lens aperture diaphragm is used to regulate depth of field, supply of light and to make the exposures convenient lengths. But, when objects are placed in the carrier for enlargement, the diaphragm when stopped down far enough enables you to get sufficient depth of focus to render the image sharp all over.

arranging other accessories

If you are going to use glass sheets clean them thoroughly beforehand, put them on one side where they will not be kicked and have the supporting blocks near at hand.

Place your dishes (trays) at a reasonable distance from the enlarger so that the paper, objects or baseboard do not get accidentally splashed. Arrange the developer—stopbath—fixer, or developer—water — fixer, in that order, and provide for a final wash under running water (the sink). Position a safelight over the dishes but not too near the enlarger baseboard or it becomes less easy to see the image from projected objects, and casts strong shadows from any objects arranged on the paper, which can be confusing.

Additionally you need a heavy sheet of glass that can be firmly clamped or weighted down when you come to make positives from your paper negatives.

Finally, there should be a reliable timer if possible fitted to the enlarger light.

Keep the paper within easy reach on the opposite side of the enlarger to the dishes. Paper is easier to handle if it is removed from the inner envelope and kept in its cardboard box (with the lid on) in a drawer. A few sheets could be kept ready like this. But if the box is in the open you need the inside envelope as well as

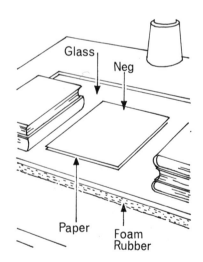

Glass, weights for printing.

110

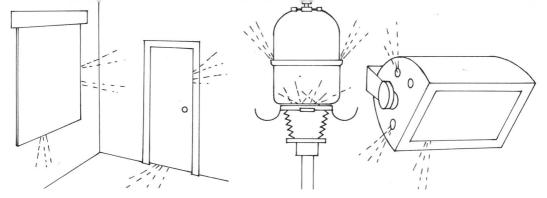

Light leaks could come from a window blind, door, enlarger or safelight.

the box itself to protect the paper from the light when you switch on the light to examine your results.

Check the temperatures of the solutions before starting. Rinse your hands before you handle paper. Use the red filter over the enlarger lens if you really need to, otherwise switch off the enlarger after every exposure.

light leaks and fogging test

As a final precaution before starting work you can test your environment for light leaks strong enough to fog the materials. With any lengthy enlarging process a light-tight room is of great importance, much greater than when making ordinary prints relatively quickly. The paper may be lying on the enlarger base-board for a total of some minutes while you are arranging or re-arranging items for each exposure.

The main worry is that stray light may reach the paper from the enlarger or from the room itself. Fogging on a print takes the form of a dull grey cast covering the whole picture so that even the highlights appear greyish when compared with the white of the paper base. This can easily be distinguished from overexposure where the darker details cannot be differentiated from one another and the whole print looks dark rather than greyish and misty. Fogging caused by a light leak in the room usually results in an overall even grey cast. That caused by light spilling on to the paper from the enlarger or safelight nearby usually appears as dark clouds in certain areas of the print.

It is better to switch the enlarger on and off rather than just cover the lens between exposures when making photograms to minimise the risk of light spilling from the lamphouse or carrier stage. When the enlarger is used this way fogging is rare but take care to mark the projected area down to no more than you need.

To test for fogging due to light leaks, place a small piece of enlarging paper on the baseboard and adjust the enlarger lens aperture so that if you give a quick flash to the paper it will develop to a medium grey tone.

To test the room for light leaks switch off the safelight and the

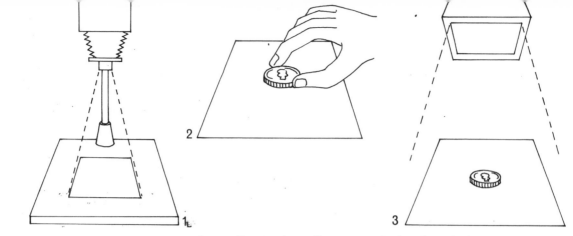

enlarger. Lay a piece of paper on the baseboard. Give a quick flash to the paper as before by switching the enlarger quickly on and off again. Now, place a coin in the centre of the paper and leave it there for as many minutes as it would take you to assemble, expose and develop your most complicated photogram, say 6 minutes. Then remove the coin and develop and fix the paper. If any difference in tone is discernible where the coin was lying then you have light leaks into the room strong enough to fog the paper. If not, then the room is light tight.

To test the safelight for fogging, repeat the first part of the test but this time have the safelight switched on. Place the paper on the baseboard and flash the enlarger on and off. Place the coin in the centre and leave the paper in position for the same length of time as before. Develop and fix the paper. If there is an even tone all over then both the safelight and room are safe. If there is a fog, it is caused either by the safelight or the enlarger.

To test for fogging from the enlarger, switch off the safelight, give the quick flash to the paper as before, place the coin on the paper. Cover the enlarger lens and switch it on again leaving it on for as long as you are ever likely to need it. Now switch off and develop the paper. If the place where the coin lay is distinguishable at all then the enlarger is causing the fog. If not, then you are clear of any danger of fogging, provided you have also carried out the previous two tests.

To test for chemical fogging switch off the lights, take a sheet from the box and put it straight into the developer, covering the dish. Any density after the recommended developing time could mean that the developer is either unsuitable or contaminated in some way. If this is only around the edges, the paper may have been fogged while still in the box, it might be stale, or possibly have been too long in a contaminated atmosphere, i.e. where house gas was present.

To test for leaks. Flash the paper (1) position the coin (2) and (3) leave it for a while . develop the print (4) which shows either no leaks (5) or leaks (6).

materials for photograms
the paper

Printing paper is available with more than one chemical form, two base weights, five or six contrast grades and at least a dozen **112**

surface textures and colours. Despite this multitude of alternations it is remarkably easy to make a choice. But having made a choice, it is advisable to get to know the characteristics of that particular paper and make use of that knowledge with the same materials in the future. If you change, it may mean starting from scratch again on a new test strip to get good quality and lead to endless confusion.

the base

There are two weights of paper base and photograms normally require the use of both. The 'weight' is the term applied by the paper trade to the thickness of paper and is calculated from the weight of a certain number of sheets of a particular size. These do not however concern us as photographic paper is generally referred to as single weight or double weight, double being the thick one. Double weight paper gives a print thicker and stiffer than a post-card and even a large sheet will stand up without support. It is much more expensive than single weight and is used only for final prints. The chemical make-up of the emulsion coating on it is identical to that of single weight sheets but it is usually available in a greater range of surface finishes.

Double weight paper is more or less opaque. When you reverse a photogram the first print is used like a negative. Light is shone through the base from behind and the image prints down on to the unexposed sheet beneath. Single weight paper being thinner lets more light show through and is much more suitable for making the paper negative for a photogram. Use the heavier weight only if the photogram is definitely at its final stage.

Many people prefer to use single weight paper all the time. It is less expensive and can be mounted on a card afterwards if a stiff backing is required. In fact, it mounts more easily than double weight which can develop an obstinate curl.

Besides these two forms some firms make paper in an even lighter weight known as document paper. This paper normally serves for printing document records. It does not have quite the normal quality of paper designed for printing negatives and will only produce from them the kind of gritty image favoured by some

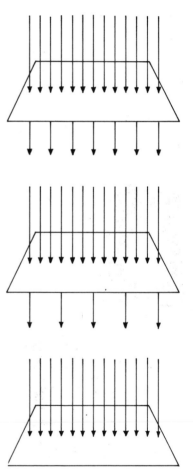

Some papers transmit more light than others.

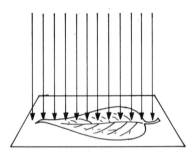

photojournalists. But it is perfectly suitable for certain kinds of photograms. Being very thin it makes an excellent paper negative and has sufficient contrast to produce a good black. It can be mounted easily but clear (not brown) mounting tissues should be used as anything else will show through. In Britain, this paper being quite rightly classified as record material does not carry purchase tax and is therefore far cheaper than ordinary enlarging paper.

paper surface

The surface texture of a photographic paper is of greater importance in conventional photography than for making photograms. But some surfaces are more useful than others. The final print can be on paper with virtually any surface. Glossy paper renders a very good black and may seem ideal to some people. But the various matt surfaces are very suitable for a photogram. Even those more unusual ones such as linen and strongly patterned lustre types can look right with certain photograms, while dead matt and matt surfaces are suitable for almost any.

Unglazed glossy paper has a rather matt appearance but with a slight surface sheen. The choice of paper surface for the final print is largely a matter of individual preference.

For the intermediate stage (negative) the most suitable paper surface is glossy. You do not have to *glaze* the negative, but the paper will give a good clean image without the interference of any granular structure in light and shade showing through and giving an unnecessarily grainy appearance to the final print.

The colour of the paper base is of little importance except in as much as some people prefer a creamy appearance to the highlights in the picture and others do not. There is no objection to using paper with a creamy base for either negative or final positive prints, though nowadays when the fashion is for more glaring whites a white based paper would perhaps give the print a more 'modern' appearance.

contrast and grades

The choice of contrast grade very much depends upon the type of photogram you are aiming for. A silhouette image would normally **114**

High contrast paper gives a full silhouette whereas lower contrast may show detail.

have more bite on a high contrast paper, one that reproduces fewer mid-tone densities and has a harsher gradation from white to black. A true silhouette would, given the right exposure, reproduce as simply white and black. This is particularly effective with subjects having intricate and detailed structure. But where there is insufficient density in the object laid on the paper these details may not register out at all on high contrast paper. Therefore, where mid-tones must register it is often essential to use paper of normal contrast range, though it may not give the contrasts of light and shade you would prefer.

This grade is often necessary when enlarging objects placed in the negative carrier.

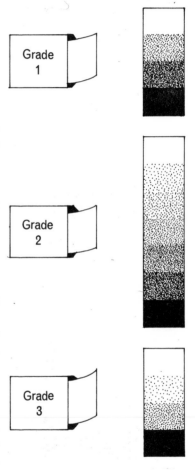

The danger with photograms that need medium or low contrast paper to show the detail is that you can end up with a muddy looking print. You therefore have to strike a balance between these conflicting factors and, wherever possible aim to get prints with as much sparkle as you can.

The contrast grades of paper range in designation from grade 0 to grade 5. These two grades are sometimes difficult to obtain but the usual working grades 1, 2, 3 and 4 are stocked by most good retailers. Grade 2 is reckoned to be normal and you may achieve good results on this. But the harder grade 3 (more contrasty) and those harder still may be needed for some jobs.

paper types

The best all round paper for photograms is Bromide and it is easily the most popular. It gives a pure black image when developed in an ordinary metol-hydroquinone developer and is safe to handle under an olive green or orange safelight. It is very light sensitive and requires quite short exposures under the enlarger to obtain an image, but can also be fogged very easily. Development time is usually $1\frac{1}{2}$ to $2\frac{1}{2}$ minutes and exposures should be based on this standard.

Chlorobromide papers give a warm black or brown-black image tone, and are not as light sensitive as bromides. They should be handled under an orange safelight, and their development time is about $1\frac{1}{2}$ minutes. A 2-3 minute development time loses the warm

Mid-grade papers give more scope for multi-tone printing.

tone.

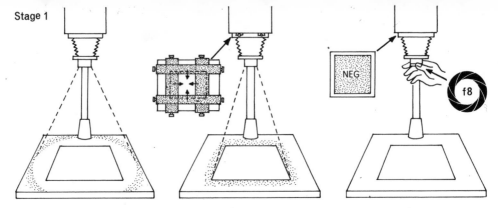

Stage 1. Switch on the enlarger and mask down to the paper area, insert the neg and set a mid aperture.

dimensions

Paper is manufactured in various standard dimensions. For a photogram you need sheets at least whole plate $6\frac{1}{2}$ x $8\frac{1}{2}$ in. size and preferably larger. Do not forget that the size of the negative determines also the dimensions of the final print. When making the positive there is no change in image size as there is with normal enlarging. The 10 x 8 in. size is a good working average, it is not too expensive, can be processed in dishes of moderate size and does not need large objects or many objects placed upon it to make a photogram.

printing

We will only summarize the printing procedure here as it is discussed in some detail in an early chapter. But here a few further points of help and interest can be added:

stage 1

Place a sheet of plain paper (same size as the eventual print) on the baseboard. Arrange the enlarger with lens fitted to throw a pool of light evenly over the paper area. Raise the head if necessary. Mask down the area of illumination to fit the paper dimensions using the enlarger masks. Insert a negative in the carrier and focus it on the paper. Remove the negative and reinsert the carrier. Stop the lens down to, say, $f8$. Switch off.

stage 2

The test for exposure: This test is to find how little exposure you need to obtain a good black with your light source uninterrupted. Place a small piece of bromide paper on the baseboard. Switch on and expose steps across this paper at 2-second intervals. Switch off and develop the print for the recommended time and fix. You can turn the light on after 15/30 seconds or so to examine your test strip (using fresh solution). If no black appears your exposures are altogether too short. If the whole strip goes black they are too long. In the first case, open the lens by two stops to $f4$, **116**

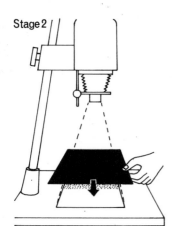

Stage 2. Make a test strip in two-second steps.

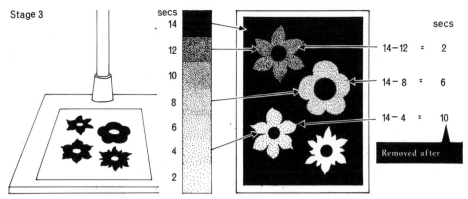

e 3. When printing remove objects as indicated by the test to get the same densities for each.

in the second close it by one stop and try again. Note the *first* step showing pure black, and base all your exposures on the time it took to reach that. Give yourself a reasonable working exposure. If the time is 6 seconds stop down a further stop to make it 12. This length of time is necessary in order to do any dodging or printing in. If you anticipate more complicated printing procedures you can stop down a further stop increasing the basic working exposure to 24 seconds. You should also try this longer set of exposures if you find evenly graded shading or burning-in a difficulty. A further stop would give a 58-second basic exposure.

stage 3

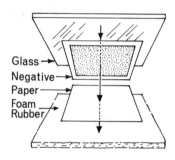

Making the print. Place a sheet of bromide single weight paper emulsion upwards on the baseboard. Arrange the objects so that those to be removed first are on the top glass. Divide the total exposure time (as detailed in the preceding illustrated chapters) into units of 2 or more seconds apiece. The objects retained for the longest times will give the whiter image. The background of the negative on a one-stage photogram is always black. Be sure that at least one part of the print receives the full exposure time. Develop this print for the usual time, wash and fix. Maintain exactly the same time for your prints as you did for the test, otherwise the test becomes meaningless. You can turn the light on to inspect your print after 15 seconds or so. But unlike the test strip the print must be fixed for the full recommended time (see instructions) normally about 10 minutes, or 2 minutes with rapid-action fixer. Do not leave them in longer as the fixer tends to bleach the print after prolonged soaking. Wash thoroughly for 10 or 20 minutes.

stage 4

Making the positive, or final print. Place a small strip of double weight (or single weight) paper on the baseboard emulsion side (shiny side) upwards. Lay the negative print (which must be thoroughly dried) on top of it emulsion side or image side downwards, so that they are face to face. Be sure that the test strip **117** includes some of the lightest as well as the darkest area on the nega-

Glass
Negative
Paper
Foam
Rubber

Stage 4

Stage 4. To make the positive make a negative/paper sandwich as shown and print through.

tive so that it can represent all tones. Lay a sheet of glass over the top, pressing the two pieces of paper in close contact. Now make a series of step exposures as you did for the first test strip so that you get the full range of densities represented at each exposure. Taking the best graded result, repeat the printing with a whole sheet face upwards and the negative placed exactly over it. Lay the glass sheet (which must be clean) over the top and weight it down at the sides with substantial weights such as a couple of heavy books. Expose, develop and print the result. You should have a sharp well-defined print with good strong blacks and whites. The background will normally be white and images of the objects appear in greys and blacks. If the result has a 'gritty' appearance or the necessary exposure is unduly long try treating the back of the negatives with oil or petroleum jelly (or any similar greasy or oily substance). This will give the paper a translucent appearance and it will behave more like a film negative. A negative treated like this nearly always gives better results. Having made the print, fix, wash and dry as for the negative.

three enlarging 'utensils'

printing in

The easiest way to print-in an area is to cut a hole in a card the shape you want, but much smaller, and hold it in the light beam keeping the shape moving about in the required area for as long as you need. Keep it moving all the time and be very careful not to overlap or move the card too much. Printing-in should be under-done rather than overdone. Overdoing it gives a nasty black patch. An experienced printer, however, more often than not uses only his hands.

By holding them together in the light beam he can make any size or shape of light patch for burning in. This takes consider-able practice and is not recommended unless you are prepared to waste plenty of paper. When you are good at it you can shade, dodge and print-in much more quickly than by any card cutting method.

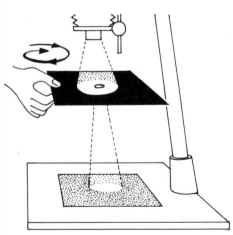

Printing-in with a card.

dodging

This is the opposite to printing-in. You are restraining the light falling in a certain area for part of the exposure time. The simplest way is to use a dodger. A versatile dodger can be made from a piece of wire bent into a small loop at one end with a small wadge of modelling clay squeezed over it in a flat disc shape. The clay can be reshaped to suit the area to be dodged. The wire is too thin to register on the print. Larger or special shapes can be cut from stiff paper and stuck to the loop end with adhesive tape. It is a good idea to keep a simple dodger whose characteristics you can get to know well. You can get quite expert with this and you may do most work with it eventually.

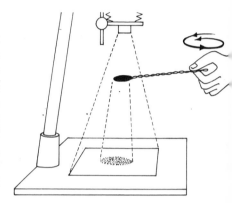

Using a dodger.

timing

A darkroom timer, a sort of alarm clock with a sweep second hand, is a useful aid to accurate timing. Better still is the timer on the current supply going to the enlarger. With this you set the time in advance. When you press the plunger, it switches on the enlarger light and after the requisite number of seconds' exposure switches it off again.

repeat printing

Very few photograms can be repeated exactly. Some with hinged masks can give results nearly identical. But whether they can be repeated or not, it is much less trouble to use some method of making copies of the print you already have. All but the simplest photograms involve several stages in their preparation and it is tedious to repeat these for each print.

With negative-positive photograms, duplicating prints is easy. You simply repeat the printing stage. With direct positive ones there is greater difficulty. Either you must make a paper negative from the positive and then produce more positives from that or you can copy the positive with a camera and make a print from the camera film in the normal way. The first method usually results in a great deterioration in image quality however careful you are. The

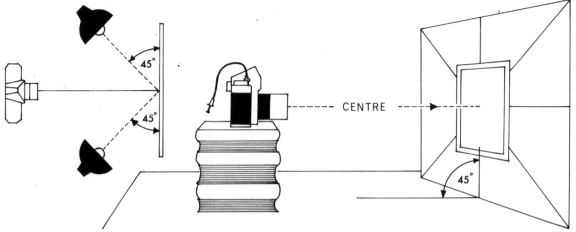
Camera set up for copying a one-stage photogram to make further copies.

second is more likely to work if you use the right film and print on the correct paper. All the same, you can usually tell that a print has been copied with a camera. But there is no alternative open to you so you just have to make as good a job of it as you can.

Choose a fairly contrasty film of fine grain. Almost any of the slower emulsions fit this description. Be sure that your copying camera is square on to the print, that the lighting is quite even, and there are no reflections or sheen coming off the paper surface. Take several exposures. Pick the negative that seems to have the best tone range if there are tones. If it is a contrasty photogram with no mid tones at all, just black and white, use a very slow high contrast film. Slight under-exposure (compared with a straight exposure reading off the print) and full development will give higher contrast. Print the negative on grade 5 paper giving normal processing time. This will give high enough contrast for most jobs. Failing this you may have to use special line or litho film with its own maximum contrast developer and print on grade 5. But these materials are not as easy to handle as the conventional ones, and unless you know how, results can be inferior. They are expensive and cannot be purchased in the average photo shop.

INDEXED GLOSSARY

124

125 NEG.-POS. negative-positive process. Where one is

ber of distinct and separate tones — each of uniform density. A continuous tone image is composed of a range of densities from black through grey to white. The range of tones in a photogram may extend only from mid-grey to black, but in any continuous tone image there is no separation or sudden break between tones — in many areas they blend from one to the other

TONING a process for colour-staining a photographic print. Several chemical methods exist and proprietary toners are manufactured in a range of colours. A less complicated method is to dye the print in ordinary dyes designed for household use. Photograms may be dyed selectively by using a resist

WASH two washes are required in making a photogram, a short one after development and before fixing and a longer one in running water after fixing

WHOLE PLATE a standard size of printing paper $6\frac{1}{2}$ x $8\frac{1}{2}$ ins